U0164798

楊式
簡化太極拳

高樹興
Ko Shu Hing

鄧敏佳
Minjia Deng

Yang Style Simplified Tai Chi Chuan

掃碼優酷學習

掃碼 YouTube 學習

聯繫出版社

WhatsApp

香港國際武術總會

目　　錄
DIRECTORY

前言 ...06
preface

高樹興簡介 ...08
Profile of Master Ko Shu Hing, Kelvin

鄧敏佳簡介 ...10
Introduction to Deng Minjia

序一　鄭鳳池 ...12
Preface 1 Zheng Feng Chi

序二　翁宗榮 ...13
Preface 2 Weng Zong Rong

序三　梁耀光 ...14
Preface 3 Liang Yao Guang

序四　吳澍仁 ...16
Preface 4 Wu Shu Ren

序五 Dr Samuel Alexander Beatson, Ph.D.18
Preface 5

序六　白耀燦 ...19
Preface 6 Bai Yao Can

序七　霍永浩 ...19
Preface 7 Huo Yong Hao

序八　陳超揚 ...20
Preface 8 Chen Chao Yang

序九　謝振威 ...21
Preface 9 Xie Zhen Wei

練習方向和定勢方位示意圖36
Illustrations of Practice Position

太極二十四式38
Tai Chi 24 Forms

動作教學與圖解40
Decomposition and Teaching

《國際武術大講堂系列教學》
編委會名單

名 譽 主 任：冷述仁

名譽副主任：桂貴英

主　　　任：蕭苑生

副　主　任：趙海鑫　張梅瑛

主　　　編：冷先鋒

副　主　編：鄧敏佳　鄧建東　陳裕平　冷修寧　冷雪峰　冷清鋒

　　　　　　冷曉峰　冷　奔

編　　　委：劉玲莉　張貴珍　李美瑤　張念斯　葉旺萍　葉　英

　　　　　　陳興緒　黃慧娟（印尼）　葉逸飛　陳雄飛　黃鈺雯

　　　　　　王小瓊（德國）　葉錫文　翁摩西　梁多梅　ALEX（加拿大）

　　　　　　冷　余　鄧金超　冷飛鴻　PHILIP（英國）金子樺

　　　　　　高樹興

顧　　　問：何光鴻　柯孫培　馬春喜　陳炳麟

法律顧問：王白儂　朱善略　劉志輝

《楊式簡化太極拳》
編委會名單

主　　編：高樹興　鄧敏佳

副主編：高日明　冷飛鴻

編　　委：練錦河　梁國華　曹振坤　袁思珍　羅紹永　林文英　伍偉南

　　　　　蔡薈蓮　鄒森娥　溫亞好　潘瑞銀　翁宗榮　陳月明　姚美貞

　　　　　梁景霞　梁景華　程文堅　周淑芬　姚嫣婷　黃國禎　鄧金超

　　　　　張永娥　勞富強　黎沛良　楊滿鴻　陳兆麟　黃偉熙　鄧衍良

　　　　　余澤倫　張偉民　甄佩娟　鄭志豪　林嘉麗　何佩芳　冷　余

　　　　　劉玲莉　吳天成　許依玲　張念斯　葉　英　鄭安娜　張晉豪

　　　　　鄧建東　陳裕平　張貴珍　周煥珍　冷飛彤　葉旺萍　陳興緒

　　　　　何淑貞　戴裕強　梁多梅　金子樺　楊海英　余　瓊　陳　璐

　　　　　張艷玲

謝經緯　榮譽康體適能與武術顧問
　　　　CSCS,ACSM EP

Roy Tse　Honorary Health Fitness and Wushu Consultant
　　　　CSCS, ACSM EP

前 言

　　"楊式簡化太極拳"又名"24式太極拳"。是1956年原國家體委運動司武術科（現國家體育總局武術運動管理中心）組織有關專家編寫的。按照由易到難、由淺至深的原則，在原有傳統楊式太極拳的基礎上進行改編、整理而成的，即保留了原有套路中的主要內容和技術風格，又便於初學者掌握，易學易練。全套分為八個小段，學練者可根據身體情況選擇整套或分段練習。

　　《楊式簡化太極拳》是香港國際武術出版社太極拳系列叢書之一，接下來會出版其他門派如《陳式簡化太極拳》、《吳式簡化太極拳》、《武當簡化太極拳》等。本書中英文版，文字詳細，通俗易懂，配有全彩色高清照片，每一個動作方位準確標註，手腳變化畫有動態線，二維碼視頻教學。出版後很快在海內外各大書店、圖書館暢銷書類目上架，特此向廣大武術太極拳愛好者推薦此書，希望大家喜歡。

　　本書作者高樹興和鄧敏佳師傅，都是資深太極拳師傅，而且都接受過高等教育，高師傅在美國夏威夷大學畢業；鄧師傅在廣州大學畢業，可謂文武雙全。

　　高樹興師傅，任教香港大學和香港大學專業進修學院二十多年，教授各派太極拳，具有非常豐富的教學經驗，培養出幾百位從事武術工作的教練員，桃李滿天下。

　　鄧敏佳師傅，當代青年武術家，多次榮獲比賽冠軍。現任多間學校的武術顧問、總教練。著力培養青少年的武術太極拳，從小學、幼兒園抓起，推廣中國優秀傳統文化，建立文化自信，前途不可限量。

<div align="right">

香港國際武術總會主席　冷先鋒

01-09-2021

</div>

preface

 "Yang style Simplified Tai Chi Chuan" is also known as "24-form Tai Chi Chuan ". It was compiled by experts from the Martial Arts Department of the former State Sports Commission (Current Martial Arts Management Center of the State General Administration of Sports) in 1956.

 It is based on the traditional Yang Style Tai Chi Chuan. It aims to simplify the complicated Tai Chi forms and presents them in a progressive manner while retaining the main contents and the technical style of the original routine. It is easy for beginners to learn, practice and master.

 The whole set is divided into eight segments. Learners can either practice the whole set or choose different segment according to their own choice or physical conditions.

 "Yang style Simplified Tai Chi Chuan" is one of the Tai Chi Chuan book series of Hong Kong International Wushu Publishing House. In the near future, books of Tai Chi Chuan from other Sects will be published, such as "Chen Style Simplified Tai Chi Chuan", "Wu style Simplified Tai Chi Chuan", "Wudang Simplified Tai Chi Chuan" etc.

 All texts are printed in both Chinese and English, with detailed descriptions of all the forms of Tai Chi Chuan movements. Each form is illustrated with demonstrations pictured in high-definition color photo. All hands, feet and body movements are clearly indicated to facilitate readers' understanding. For those who prefer video learning, a QR code is attached in the tutorials.

 This book is available under the "best-selling" categories in major bookstores and libraries home and abroad. I sincerely recommend this book to all Martial Arts and Tai Chi Chuan fans and believe you will benefit from it.

 The authors of this book, Master KO Shu Hing and Master DENG Minjia, are veteran Tai Chi Chuan masters who are scholars with high educational background and professional training.

 Master KO was graduated from the University of Hawaii in the United States. He has been teaching Tai Chi Chuan at the University of Hong Kong and the School of Professional And Continuing Education (SPACE) of the University of Hong Kong for over 20 years. He has vast teaching experiences and has trained hundreds of coaches who further branched down to teach different forms of martial arts.

 Master DENG was graduated from Guangzhou University. She is a contemporary young martial artist and has won numerous championship titles in her career. She is currently a martial arts consultant and as the head coach of a number of schools. She aims to cultivate young martial arts and tai chi talents from the kindergarten and primary school level, to promote traditional Chinese culture and to build up national pride. She is with boundless future aspiration.

<div align="right">

LENG Xianfeng
Chairman of the Hong Kong International Wushu Association
September 2021

</div>

高樹興簡介

本人自小已愛上踢足球及各類運動。
從小四至中四的七年間，連續代表聖類斯
學校足球校隊正選。畢業後遠赴美國夏威
夷大學，修讀工商管理學士，於畢業後再
回港工作。

在 1995 年，岳父有見我因舊傷而致及
脊骨漸見退化積象，他便親自授教我耍楊
家太極拳復健。掌握基本功後，為了再加
深鑽研，便再加修習傅家太極拳。期間勤
加練習，除了身體狀況大有改善外，更令
我愛上太極這門活動。其後更修研成為教練，好向大眾推廣太極對健康之
裨益，又有弘揚中華武術的志願。

在之後 1998 至 1999 年間，我先後獲認證為香港太極總會太極拳及劍
術教練、香港武術聯會一級教練和散打裁判。更有幸榮獲鄭鳳池師傅提攜，
在 1999 年於香港舉辦的第五屆世界武術錦標大賽擔任散打裁判的殊榮。

及後我參與多間中小學、康文署等機構合作教授推廣太極，亦開設私人
班授徒，慢慢累積授教經驗。從 2000 年起，有緣能可於香港大學及香港大
學專業進修學院教授太極學術科目。其下包括吳家基本套路太極拳、太極氣
功、太極扇，及楊式簡化太極拳等等，至今連續已辦逾二十年。

與此期間，我也在 2005 年起兼任香港大學專業進修學院及香港特區政
府教育署合辦的武術技能提升課程總教練。課程先後一共舉辦了廿八期之多。
回想起來，這些寶貴經歷都令我獲益匪淺。最慶幸的都是能結識到來自世界
各地、各行各業、不同年齡的一眾學生及太極愛好者，令本人增添了不少人
生閱歷，亦慶幸可以為普及太極和香港武術活動能稍盡了少許綿力。

Profile of Master Ko Shu Hing, Kelvin

I have been a fervent lover of sports and soccer ever since I was a boy. In the 7-year span from Primary 4 to Form 4, I represented and played in the school soccer team of St. Louis School. After my high school graduation, I furthered my studies abroad in the University of Hawaii and attained my Bachelor Degree in Business Administration (First Honour). I then returned to Hong Kong for my career development.

In 1995, my beloved father-in-law was kind enough to pass on to me personally his "Yeung Style" Taichi skill and practices after I suffered from my chronic spinal degeneration problem. After some basic training, the "Fu Style" was introduced into my training programme also. During the subsequent training years, my bodily health improved significantly and I gradually developed fond affections to Taichi activities. Later on, I furthered my aspirations to become a Taichi instructor so that I can introduce the benefit of Taichi to the general public as an exercise in improving health as well as promoting the art of Taichi in the Wushu culture arena.

From 1998 to 1999, I was accredited as Taichi Instructor, Taichi Sword Instructor by The Hong Kong Taichi Association. In 1999, I was endorsed by Master CHEUNG Fung-chi and further given the honour as the judge of The Chinese Free Boxing (Sanshou) Competition in The 5th World Wushu Championship Competition hosted in Hong Kong.

In these years, I continued to take part in various Taichi instructional and promotion activities organised by primary and secondary schools, Leisure and Cultural Services Department (LCSD) etc. I also started my Taichi personal and tutoring classes; during which I gathered precious coaching experiences. Since 2000 till present, I have the opportunity of teaching and promoting Taichi as one of the subjects organized by HKU and HKU SPACE Program which include Wu Style Tai Chi Chuan，Qigong, Tai Chi Fan and Yang Style Simplified Tai Chi Chuan.

In 2005, I was additionally tasked as the Chief Taichi Instructor in the "Wushu Skills Upgrading Scheme Programme" co-hosted by HKU SPACE and the Hong Kong SAR Education Bureau. There were a total of 28 classes held so far.

In retrospect, I feel very comforting and gratifying to have been blessed with the opportunities in making acquaintances with people of all races, ages, trades whom are followers of one goal – Taichi. These interactions have enriched my quality of life significantly, though in comparison, I have only contributed so little in promoting the philosophy of Taichi.

鄧敏佳簡介

鄧敏佳老師，1983 年出生於廣東梅州，畢業於廣州大學，自幼習武，世界非物質文化遺產傳承人；香港全港公開太極拳錦標賽冠軍；國際武術邀請賽 50kg 推手冠軍；國際武術高級

我的孩子是从小学习太极的

教練員、高級裁判員。師從當代武術名家、全國武術太極拳冠軍、陳氏太極拳第十一代正宗傳人冷先鋒老師。

　　鄧敏佳老師擔任香港國際武術總會副主席和總教練，被多間學校聘為武術顧問、總教練，並積極參與一些社會公益推廣活動。從 2006 年以來開始在香港和中國內地開設培訓班傳授太極拳，所教學生數千人，其學生在國內、國際武術比賽中，獲得獎牌數百枚。鄧敏佳老師曾應邀赴美國、英國、日本、澳大利亞、印尼、新加坡、臺灣等國家和地區進行交流、講學及裁判工作。多年的教學鑽研，對太極拳頗有造詣，為國內外培養了一大批優秀的太極拳教練員及運動員，為推廣武術太極拳運動的普及、健身及競賽做了大量的工作，為把太極拳運動推向世界作出很大的貢獻。同時，鄧敏佳老師在太極拳傳授與學習中，以青少年獨特的視角，把太極陰陽平衡、以柔克剛的拳理與青少年自強自立的品格相結合，傳播傳統武術運動和時尚運動相融合的理念，倡導更多青少年參與練習太極拳，讓更多的青少年愛上太極拳運動，強身健體、陶冶情操。

Introduction to Deng Minjia

Ms. Deng Minjia was born in Meizhou, Guangdong Province in 1983. She was graduated from Guangzhou University and practiced Martial Arts since childhood. She was nominated as an inheritor of the World Intangible Cultural heritage. Ms Deng has won a lot of accolades in her career, including Champion of the Hong Kong Open Tai Chi Chuan championship and 50kg champion of International Wushu Invitational Competition etc. She is also an International Wushu Senior Coach and Senior Referee.

Last but not least, she is a student of a famous Martial Artist Mr Leng Xianfeng, who was a National Champion of Tai Chi Chuan and the 11th generation authentic successor of Chen Style Tai Chi Chuan.

As the Vice Chairman and Head coach of the Hong Kong International Wushu Association, Ms. Deng Minjia is also the head coach of many schools, and has actively participated in various social welfare activities.

Since 2006, she has been teaching Tai Chi Chuan classes in both Hong Kong and Mainland China. There have been thousands of students all over the years who have learned from her. Her students have won hundreds of medals in domestic and international Wushu competitions.

Ms. Deng has been invited to the United States, Britain, Japan, Australia, Indonesia, Singapore, Taiwan and other countries for exchanges, lectures and referee work. After years of teaching and research, she is very accomplished in Tai Chi Chuan, who cultivated countless excellent Tai Chi Chuan coaches and athletes home and abroad. Besides, she dedicated herself to promote Tai Chi Chuan to the world.

Through continuous learning and teaching the art of Tai Chi Chuan, Ms Deng instilled Tai Chi Chuan's Theory of "overcoming brute force with dexterity", "Balance of Yin & Yang" to the youngsters to promote strong will and self-reliance. Ms. Deng aspires to promote Tai Chi Chuan as a trendy sport while retaining its traditional elements, in the hope that Tai Chi Chuan will become more popular among the younger generations.

序一：武術的迴旋

武術的迴旋

為什麼人們總是在生命的洪流裏，隨著業海漂泊掙脫不起呢？是不是就因為欠缺那一點點的得度因緣？

余設帳授教，至今可謂浮生半世，長年的武遊生涯，處理過無數個案，生命在於運動，是無庸置疑的。

高師傅樹興賢兄自小學開始，已經愛上體育運動，從後來赴美國夏威夷大學，完成工商管理學士學位，便回港工作。

1995 年因瘠骨出現退化，他深信武術的寶貴，便學習太極拳，瘠椎得到改善，因而愛上習耍太極拳; 先後考獲了香港太極總會太極拳械及香港武術聯會教練員及裁判員等證書。於 1999 年香港舉辦的第五屆世界武術錦標賽事，余被香港武術聯會委任競賽處主任一職，時期與他並肩順利完成裁判隊伍和競賽處等工作，任務其間，高樹興師傅在分工崗位上，負責果斷及表現卓越，我們成功完滿了這次盛舉；除此，余也和高樹興師傅合作主辦在佐敦三軍會的 "武術縱橫談講座"，事次參加者來自不同門派，各路精英，宏集三百餘眾，反應熱烈，大眾獲益良多，講座成功達到了大會要求的發展推廣的目標，至今我們談起，還是津津樂道，無限歡心。

高樹興師傅的授武教學，可說風雨無間，作育英才，持之以恆，貢獻武林。約 2001 年至今，高樹興師傅在香港大學、香港大學專業進修學院任教太極氣功、吳家基本套路太極拳、太極氣功、太極扇及楊式簡化太極拳等武術。更在 2005 年，任香港大學專業進修學院及教育學院合辦的武術技能提升課程的主講導師，一共舉辦了二十八期，余極動鼓勵及支持，也義務當了課程的武術顧問，五年期間，訓練出幾百位從事武術工作的教練員。

高樹興師傅，學貫中西，他尊重及敬愛同行，口才了得，對武術有見地，有很好的提議，他尊師重道，愛護徒兒，深明為人師表者肩負著薪火相傳之使命，你願意學他便樂於教。今喜悅知悉高樹興師傅的楊式簡化太極拳一書即行面世，承蒙邀請，特撰文，祝寶典馬到功成，發揚光大，造福社群，萬民得度因緣。

<div align="right">

1990 年北京亞洲運動會

2008 年北京奧林匹克運動會武術總裁判長

1999 年全港體育傑出貢獻獎

北少林八卦門永遠會長

香港鳳翎武相主席

2021.09.03 鄭鳳池

</div>

序二：由「同學緣」到「太極緣」

高樹興師傅是我小學、中學、大學時的同學，是我學習太極時的師兄。

我認識高師傅已有六十年。在茫茫人海中，要和其中一人交往六十年，那肯定是有某種緣份使然，我和高師傅的緣份，大概就是同學緣。六十年前，我考進了聖類斯小學三年級，被編入「小三丙」這一班，高師傅也是其中一位新生，我和高師傅就從這時開始認識。小學畢業後，我們從聖類斯小學直昇中學，並在同一班中渡過了五年中學歲月。

在中、小學這段期間，我和高師傅不算熟絡。高師傅是運動健將，熱愛足球，是校隊的中堅份子，我喜歡較溫文的活動，如聽音樂，看電影等，我們各有各的同學圈子。中學畢業後，各奔前程。我在香港讀完災難性的兩年預科後，去到位處太平洋中心的夏威夷，繼續我的學業。經過了第一年的適應期，第二學年開始，我已完全投入了新的生活，而香港的一切，也已漸漸變得遙遠，糢糊。就在這時，有一天在校園裏，高師傅忽然出現在我眼前，這令我喜出望外，能在千里迢迢之外和舊同學相遇，實在是難得的事。了解後，知道高師傅也報讀了夏威夷大學，主修商業管理，自然而然，我和高師傅又成為了同學，又一次印証了彼此之間的同學緣。我和高師傅同時在夏威夷大學就讀的日子，約有三年。由於主修的科目不同，喜歡的活動不同，朋友圈也就不同。這三年裏，我們偶有碰面，但來往不多。高師傅比我早回香港，回港後在商界發展。我大約後他一年回港。跟着約有十年，由於各有各忙，我們基本上沒有甚麼聯繫。

後來，我和高師傅先後加入了香港的一個扶輪社，成了社友，見面的機會就比較多了。也就在這時期，我開始聽高師傅提及太極拳，並透過他的引薦，和另外幾位社友，參加了一個太極拳學習班，高師傅當時是這個學習班的助教，可以說是我的師兄。我參加了這個學習班大約半年，學了楊家太極拳二十四式，之後在家中作為一種養生運動練習。高師傅就繼續鑽研太極，並考取了太極教練證，開始授徒，最終將太極帶進了大學殿堂，成為大學提供的一門課程，將太極的理念和實踐方法，介紹給來自世界各地的莘莘學子。

回顧高師傅的太極路，可說頗不尋常。他並非自幼便學習太極，年青時他喜愛的是足球，一種激烈而充斥肢體碰撞的運動。大學畢業回港後，高師傅在商界發展，而商界的基本規則，是你死我活的競爭。高師傅遇上太極時，應該已是壯年，他取得教練證後，在很短時間內便建立起自己的弟子群，並將太極帶進大學，這實在是很罕見的一種成就。太極的理念，是中華文化很重要的一個構成部份，也是人類文明的一種瑰寶。太極和高師傅之間，應該是有一種緣份，令他們結伴同行，令高師傅成為太極的一個代言人，將太極的理念向世界推廣。

如今，高師傅將出版一本以中英雙語介紹太極的著作，作為一個與高師傅有同學緣的老同學，我謹祝高師傅繼續發揮他和太極之間的太極緣，使太極理念廣傳世界，造福人間。

翁宗榮

2021.09.08

序三

時維二〇一九年八月某日，收到老同學高樹興的電話。寒暄數句之後，他突然說有要「定罪」於我的意圖，又要我「認罪」。當時一刻，我即有一種驚恐感覺，以為我做錯了什麼得罪了他。及後弄清楚，原來他的原意是「定」了我給他的太極作品寫「序」，要求我接受「認」同給他寫「序」文。

電話收線之後，反覆思量，還是攬不清楚他為什麼要我這對太極一竅不通的老人為他寫序文呢？但基於多年交情，我也要從我這非認識太極角度者來看，來為他動筆作鼓勵鼓勵。

本人與高樹興認識於微，朔於一九六零年小學三年級時期。及後一直同校同級同班至中五畢業。可以說整段從童年有認知期至青少年成長期的學校時光都一同共渡過，共享有過這段早期人生階段的寶貴共同歷程回憶。

高兄自小都是一名活躍份子，差不多所有體能活動他都十分樂於參與。尤其是對足球更加熱愛，積極參加班際至校際足球比賽為班為校爭光。高兄與本人也曾是當年班際及校際四乘一百公尺接力田徑隊跑手之二。

高兄一向為人爽朗，性格率直硬朗，敢於發聲，暢言未懼，頗有江湖風範。同級的同學甚至同校的學生均對他有深刻的印象。中學畢業後，鑑於種種客觀環境原因，同學們都有着不同的志向，分別各自尋求升學或就業的路途。及後更各在個人、生活、事業、婚姻、家庭的人生旅程中忙碌經營打拼。所以當年我曾經與絕大部份同學"失聯"了一段長時期。

及後因緣際遇，在某些場合大家同學有機會見面小敘。得悉高兄當年學成歸港之後，曾一度在商界有所成就，之後卻轉向嚮往太極學術方面求進。此舉當時曾令我非常懷疑他的持續性。但後來事實證明我的看法是錯誤的。也許他從太極中能領略到「動」與「靜」、「剛」與「柔」之間的陰陽調和，使他在個人性格中取到了成功的平衡點。

這二十多年來，高兄在太極圈子的貢獻及成就，是有目共睹的。在他的教導教訓下，很多學員都認識到太極的真締，是以修心、強身、健體為依歸，而非流於孔武拳腳或揮手踢腿之表演。

在此，本人謹祝賀高樹興師傅這本太極著作，能令更多讀者體會到太極全方位的認識。

梁耀光
二〇一九年九月

14

Preface 3

It was in a hot and rainy August evening in 2021 when I received a phone call from my old pal Kelvin KO. In the brief telephone conversation, he asked me to write something on his publication about Taichi which is about to be published soon.

After the phone call ended, I was still perplexed and uncertain why Kelvin had tasked the assignment to me, as an outsider who has no knowledge about Taichi or never have been connected to any Taichi or Wushu activities. Since we are old pals for decades, I felt obliged to put in something for his debut publication as a form of encouragement.

Kelvin and I knew each other way back in 1960 when both of us were admitted to St. Louis school as primary 3 classmates together. Since then, we were in the same Form and same Class until our Form 5 school certificate graduation in 1969. This 9-year period represented the most treasured lifespan from our cognitive childhood years to our maturing youth years, within which we both shared common and precious memories.

Kelvin has always been an energetic person. He was fond of almost every type of sporting activities, especially soccer. He took part in our inter-class and inter-school soccer teams and faired good results. In fact Kelvin and I were the two relay runners in the 4 x 100 metres relay team of our class and school teams.

With an outgoing and stronghold character, Kelvin has always been an outspoken and verbose person expressing himself free-reined and speedy in action. His famed personality is well known among our old classmates as well as other students in the school. After our secondary school graduation, our classmates all searched for different tracks for either pursuing future studies or to start their working life. It carried on further to our personal career development, marriage and family trails in the decades thereafter. Therefore I had once lost contact with the majority of my classmates for quite some years.

Fate later brought us back together during some occasional small sized gatherings. I then learnt that Kelvin was a successful businessman before but later evolved to become a Taichi enthusiast in the last 20 odd years. I once had high suspicion to his sustainability in Taichi. Later on, I was proven incorrect. May be Kelvin was indoctrinated by the Taichi co-existent principles of agility versus calamity, stiff versus soft, Yin versus Yang, within which he has found himself the balancing point in his life.

In the past 20 years or more, the success and contribution of Kelvin towards Taichi were obvious. Under his coaching, hundreds of Taichi students or followers all understood the truth and spirit of Taichi as an art to pacify one's heart and to enhance one's health, not just a gimmick martial show of punching fists or kicking feet.

I heartily congratulate Kelvin in publishing this "Yang Style Simplified Tai Chi Chuan". I sincerely hope that more and more readers can have a better comprehensive understanding on Taichi.

Andrew Y K Leung
September 2021

序四

　　太極拳是一種普遍的運動，有很多流派，各有不同的特點。許多研究發現，太極拳對健康大有裨益；它可以改善關節的靈活性、肌肉力量、肌肉耐力、平衡、姿勢、認知、甚至記憶。改善記憶效果並不令人驚訝，因為太極拳有很多招式，環環相扣。由於練習時除了要記著招式，亦要記著他們的序列，又大部份的太極拳著作都以古文書寫，使大多數人不太熱衷這種運動。

　　我很高興 40 多年的老同學高樹興師傅，編寫一本關於簡化太極拳的雙語書。該書重點介紹了楊氏太極拳的風格。他沒有使用古文，亦省略了許多其他太極拳書的術語，讓這本書很容易閱讀和理解。它討論了太極拳的生物力學原理，亦描述了太極拳的招式。讓新學習者都能够通過閱讀學到太極的基本。書中重點介紹了楊氏太極拳的 24 種招式，減少了許多重複的式子，從而減少記憶的負擔。

　　高師傅在太極界縱橫了很多年；他在許多組織包括香港大學專業進修學院和一些非政府組織任教太極拳。他是認證的太極拳教練，曾教導過幾百名太極拳導師。此外，他還擔任香港大學專業進修學院和香港特區政府教育署聯合舉辦的武術技能提升課程的總教練。在 1999 年，他任第五屆世界武術大賽中散打比賽的裁判。

　　楊式「簡化太極拳」一書是雙語的，文字為繁體中文和英文。通俗易明。我謹向所有希望學習太極拳的人推薦這本書。

吳澍仁脊醫

Preface 4

Tai Chi is widespread as an exercise, martial art and health restorative activity. There are many different schools of Tai Chi with distinct features and characteristics. Many studies have found that this martial art is associated with many health benefits. It improves flexibility, muscular strength, muscle endurance, balance, posture, cognition, and memory. Given that, however, Tai Chi does not appeal to very large numbers of people. For one thing, one has to remember the many forms and sequences associated with Tai Chi. Also, many books on Tai Chi are written in ancient Chinese, which is difficult to understand.

I am delighted that Mr. Ko, my high school ex-classmate who I have now known for over 40 years, has undertaken the task of writing a bilingual book on simplified Tai Chi Chuan. The book focuses on Yang's Tai Chi style. He reduces the jargon associated with many other Tai Chi books, which employ ancient Chinese. The book is thus easy to read and understand. It discusses the biomechanical principles of Tai Chi, and describes in details the movements. More importantly, perhaps, he makes the book practical, and a novice can undoubtedly learn the basic techniques through reading alone. The book focuses on the 24 forms of Yang's Tai Chi, which involved a number of repeated Tai Chi postures and movements, and is thus less taxing to the memory.

Mr. Ko needs no introduction. He teaches Tai Chi in many different organizations, including some NGOs and the Hong Kong University HKU Space. As a certified senior Tai Chi instructor, he has coached a few hundred Tai Chi instructors. In addition, he was the head coach in a program organized jointly by HKU Space and the Hong Kong SAR Education Bureau, teaching a course on Wushu Skills Upgrading Scheme Progrmme In 1999, he judged the free combat competition in the Fifth World Martial Art Competition.

The book "Simplified Tai Chi Chuan" is bilingual, in both Traditional Chinese and English. It is easy to comprehend, and I would recommend the book to anyone who wishes to learn and understand the Yang's Tai Chi.

Dr NG Shu Yan

Preface 5

In 2011 and 2013 I was lucky enough to have been awarded to scholarships to attend the Hong Kong University School of Business to undertake MBA courses and conduct research. One of the first activities I sought to take part in during leisure time was learning traditional Tai Chi from a Master.

Although I had practised some Tai Chi for many years, I needed to be instructed in a simple way, with patient guidance.

I first met Master Kelvin Ko at the Flora Ho Sports Centre on Pokfulam Rd, where an innovative series of Tai Chi lessons was being offered for students over 10 weeks semester. During this time we would learn the first 1/6 of the Ng style of tai chi, also known as the Wu style.

For those who were really keen, Master Ko offered Masterclasses every week, with an additional hour of Tai Chi. The innovation here was the use of a Tai Chi Kung Fu Fan in the place of a sword. I experienced fantastic health, social and mind concentration benefits from this practice.

Master Ko's style of teaching is patient, thorough and step-by-step. We also learned a warm-up form which has become very famous - all in just 10 or 12 weeks, of fun, interesting and health-giving lessons.

Master Ko and I have become good friends since this time, and on occasion where I have had the opportunity to visit Hong Kong, I have taken private lessons in the beautiful Hong Kong University campus, and enjoyed meals with Master Ko, discussing Tai Chi and other matters.

Master Ko's commitment to Tai Chi in the society has been prolific, and he is extremely generous with his time in sharing his passion. He has developed many classes for Hong Kong society, providing a healthy social outlet, exercise and enjoyment for older people and for any members of the community, for example, in Sai Ying Pun, Hong Kong island.

I would urge anyone reading this book to seek out Master Ko for lesson attendance because you will enjoy the easy-going classes combined with knowledge and details of Tai Chi you will not learn anywhere else, and I wish Master Ko congratulations and wish for his good health, luck, and prosperity on his 70th birthday.

Dr Samuel Alexander Beatson, Ph.D., Executive MBA candidate, formerly student and teacher in Swire Hall, and in St John's College, HKU, student in Tai Chi of Master Kelvin Ko

序六

　　認識高樹興師傅已 60 年了，整整一個甲子。甲子是周期，過了一個甲子，又是另一個周期的開始，近來常說「活到 120 歲」，看來不會是天方夜譚了。另一個周期開始，是更新，是生命的提升。

　　高師傅少時熱愛運動，尤擅足球，場上勇猛而穩重，剛強而靈活，素得隊友的依重，是校隊的靈魂人物，場邊同學，都是他的粉絲。

　　大自然是有規律的，衝鋒陷陣，畢竟受限於年紀。我這位 60 年的老同學、老朋友，始終是運動奇材，把盤球射球，臻化為抱球拋球，走出龍門外，遊走於小周天、大周天，虛實陰陽，揮洒自如，好個華麗轉身，境界更是提升，生命也再更新！

　　學而用，用而教，教而述，今高師傅以太極心得，立言著書，誨人強身健體，悟理養生，更是惠澤讀者社群，令人佩服！

　　高樹興師傅，高興人生，樹藝授人，書成付梓，樂為之序。

白耀燦同学

10-09-2021

序七

各位書友．

　　我認識高樹興師傅已有五十八個年頭了。是自小五已經在聖類斯學校同班。從那時起便和他踢足球，打校際。他是一個很有運動天賦的人，足球踢得很出色。後來他更練習太極拳，成就超然，門徒遍香港各地，桃李滿門。現在他著書立說，故以此序恭賀，與大家共用。謝謝。

同窗好友霍永浩寫於二一年秋。

敬賀高樹興同學新書出版

棗梨傳太極
高興辨陰陽
藝言聊代序
紙貴賀同窗

作者　陳超揚

書寫　白耀燦

新書一本顯其功
中英合璧確不同
剛柔快慢隨心用
師傅一出猛如龍

作者 謝振威師傅　書寫 白耀燦

武術縱橫談 崔仲三師傅

香港武術名家 武術縱橫談

香港善導會慈善步行籌款

鄭鳳池師傅

冷先鋒、鄧敏佳、冷飛鴻

陳心惠師傅

香港大學專業進修學院太極氣功講座

香港大學技能提升課程

西營盤街坊福利會新春太極大匯演

武術縱橫談講座

小學同學

志堅太極學會講座

香港大學專業進修學院太極扇講座

香港大學太極班

香港大學工商管理碩士生太極課程

香港太極大匯演

高樹興《港大武術／養生／太極研習課程》14/06/2010 (KKo-SUS147-024-K)

香港大學技能提升課程

第八屆香港南區太極名家匯演

高樹興《港大武術／養生／太極研習課程 25/02/2011 (KKo-SUS144-027-K)

香港大學專業進修學院太極課程　　　　　　　　　　武術縱橫談講座

香港大學專業進修學院 50 周年傑出導師獎　　　　　　開心耆英迎新春表演

香港大學技能提升課程畢業相

香港大學技能提升課程慶功宴

香港太極學員

成功完成壯舉

強身健體

太極導引養生功有2,500年歷史，是中華民族集體智慧的結晶，加上歷代太極宗師不斷傳承和發揚光大的產物，使武術和養生術得以傳承下去。

高樹酋師傅說：「太極有導引養生功，是通過意念導引的運用，呼吸的控制和和體的伸緩，使生命優化，強健身體，自我鍛鍊的好結構的療法，以中醫的經絡學說、氣血理論和現代運動訓練學為基礎，結合氣功、太極和武術等，身心同練，達到身心共同健康的目的。」最簡單易行，學懂後，學員可自行在家中練習，每次練習只需約15-20分鐘，可配合緊張生活的作息人需要。

「最重要配合三點：調身、調息，鼓體運動；調意，呼吸活動；調心，意念活動。練習太極能使心靈安靜，身體的柔軟度和力度都會增加，提高行的養生之道。」高師傅強調，再是年齡過患練習太極呢？「最理想是小學五年級，他們的骨骼已有所成長，不會明顯受到影響，而且練習太極能訓練小朋友的性，增長智慧、強身健體的好處。」高師傅在香港大學�'導和及港發展研究所任教。太極其中一功能是保健氣功班導師，他坦言，以前的學生多是中國人，現在有15-20%是外籍人士，希望通過武術各門類，帶動全民運動及健康。

「我認高師傅從學習太極不多十年，練習太極後，健康有改善，因此開始帶徒從事傳學工作，他分享：「這是很值得推廣的運動，我的失眠情況有明顯改善，體驗到太極對身體的幫助。」學生籍喜樂說：「這是很值得推廣的運動，我的失眠情況有明顯改善，體驗到太極對身體的幫助。還有很多好朋友。」

香港國際展覽中心太極扇講座

武術縱橫談大合照

武術縱橫談頒獎

宋慶齡基金會太極表演　　　　　　　　　武術縱橫談

香港大學專業進修學院學員　　　　　　　慈善跑步籌款活動

與陳超揚博士　　　　　　　　　香港西營盤街坊會太極班

右思維國際幼兒園

右思維國際幼兒園畢業典禮

幼兒園教學

國際幼兒園表演

幼兒園五步拳

香港冷先鋒武術學院

瑪歌瑞特國際幼兒園

香港太極錦標賽冠軍

英國學生

陳家溝學藝

世界冠軍高佳敏老師

世界冠軍陳思坦老師

獲得推手冠軍

參加澳洲國際比賽

媒體採訪

香港武術比賽獲團體冠軍

參加香港 TVB 節目

擔任武術比賽裁判長

學校老師太極培訓

東方日報

香港仔報

明報

香港圖書館借閱

進口到國內

香港書展小粉絲　　　　　香港書展簽名會　　　　　圖書館上架

香港書店上架

香港書店

注釋
Annotation

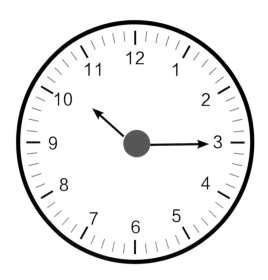

1、起勢面朝的方向為"正南方"。

The Commencing form direction is facing "the south"

2、時鐘的方向是動作定勢時胸的朝向

The direction of the clock is the direction of the body when the action is set

白：代表左腳，黑：代表右腳。
White : Left Foot　Black: Right Foot

表示腳跟着地。
Back Heels touch on the ground.

表示前腳掌着地。
Front Toes touch on the ground.

表示其中一只腳懸空的動作。
Lift up either Left or Right Foot

—————————➤ 代表右手右腳路綫 Stands for Right Hand and Right Foot Movement.

- - - - - - - - - - ➤ 代表左手左腳路綫 Stands for Left Hand and Left Foot Movement.

楊式簡化太極拳
Yang Style Simplified Tai Chi Chuan
練習方向和定勢方位示意圖
Illustrations of Practice Position

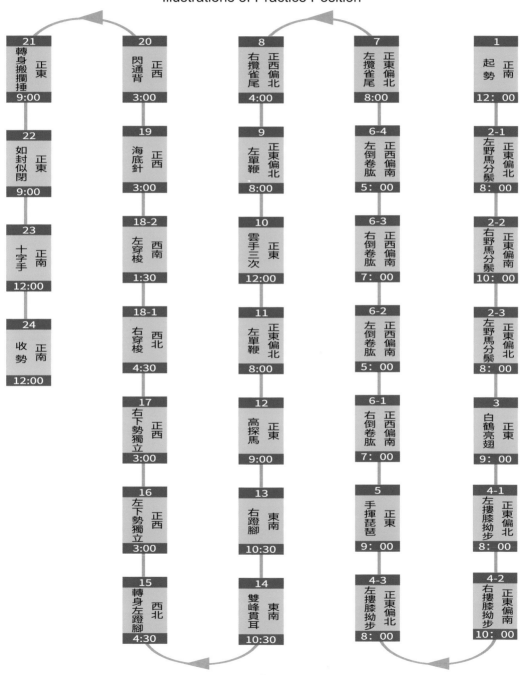

| | | | | |
|---|---|---|---|---|
| 21 轉身搬攔捶 正東 9:00 | 20 閃通背 正西 3:00 | 8 右攬雀尾 正西偏北 4:00 | 7 左攬雀尾 正東偏北 8:00 | 1 起勢 正南 12:00 |
| 22 如封似閉 正東 9:00 | 19 海底針 正西 3:00 | 9 左單鞭 正東偏北 8:00 | 6-4 左倒卷肱 正西偏南 5:00 | 2-1 左野馬分鬃 正東偏北 8:00 |
| 23 十字手 正南 12:00 | 18-2 左穿梭 西南 1:30 | 10 雲手三次 正東 12:00 | 6-3 右倒卷肱 正西偏南 7:00 | 2-2 右野馬分鬃 正東偏南 10:00 |
| 24 收勢 正南 12:00 | 18-1 右穿梭 西北 4:30 | 11 左單鞭 正東偏北 8:00 | 6-2 左倒卷肱 正西偏南 5:00 | 2-3 左野馬分鬃 正東偏北 8:00 |
| | 17 右下勢獨立 正西 3:00 | 12 高探馬 正東 9:00 | 6-1 右倒卷肱 正西偏南 7:00 | 3 白鶴亮翅 正東 9:00 |
| | 16 左下勢獨立 正西 3:00 | 13 右蹬腳 東南 10:30 | 5 手揮琵琶 正東 9:00 | 4-1 左摟膝拗步 正東偏北 8:00 |
| | 15 轉身左蹬腳 西北 4:30 | 14 雙峰貫耳 東南 10:30 | 4-3 左摟膝拗步 正東偏北 8:00 | 4-2 右摟膝拗步 正東偏南 10:00 |

太極二十四式
Tai Chi 24 Forms

第一式 起勢 ..40
Commencing Form

第二式 左右左野馬分鬃42
Parting the Wild Horse's Mane on Both Sides

第三式 白鶴亮翅 ..48
White Crane Spreads its Wings

第四式 左右左摟膝拗步50
Brush Knee and Twist Step on Both Sides

第五式 手揮琵琶 ..56
Play the Lute

第六式 右左右左倒卷肱58
Curve Back Arms On Both Sides

第七式 左攬雀尾（左掤捋擠按）..............64
Left Ward-off,Pull,Press and Push

第八式 右攬雀尾（右掤捋擠按）.............70
Right Ward-off,Pull,Press and Push

第九式 左單鞭 ..76
Left Single Whip

第十式 雲手 ..79
Cloud Hands

第十一式 左單鞭 ..84
Left Single Whip

第十二式 高探馬 ..86
High Pat on Horse

第十三式 右蹬腳 ..87
Kick out Right Heel

第十四式 雙峰貫耳 ..90
Strike Opponent's Ears with Both Fists

第十五式 轉身左蹬腳 ..92
Turn Body and Kick out Left Heel

第十六式 左下勢獨立 ..94
Left Downward Posture With Left Single Leg Stance

第十七式 右下勢獨立 ..98
Right Downward Posture With Right Single Leg Stance

第十八式 左右穿梭 ..102
Work at Shuttles on Both Sides

第十九式 海底針 ..106
Needle at Sea Bottom

第二十式 閃通背 ..108
Flash arms Through Back

第二十一式 轉身搬攔捶 ..110
Turn Body Rightward, Deflect Downward, Parry and Punch

第二十二式 如封似閉 ..115
Apparent Close Up

第二十三式 十字手 ..119
Cross Hands

第二十四式 收勢 ..121
Closing Form

動作教學與圖解
Decomposition and Teaching
第一式 起勢
Commencing Form

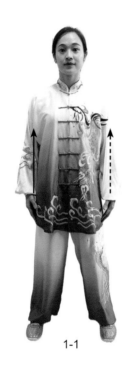

1-1

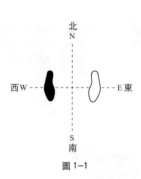

北
N

西W —·· ·—— E東

S
南

圖 1-1

1. 开步直立 Stand upright

身體自然直立，兩腳與肩同寬，兩手鬆垂輕貼大腿外側，目視前方。 （圖 1-1）

Body naturally upright, with feet at shoulder-width,arms relaxed with palms resting lightly on outside of thighs, look straight ahead.(Fig. 1-1)

第一式 起勢
Commencing Form

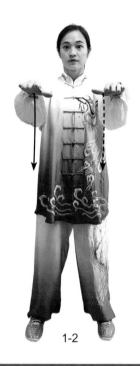

1-2

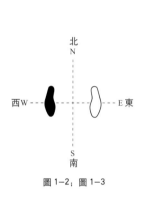

北
N

西W ─ ─ ─ E東

S
南

圖 1-2；圖 1-3

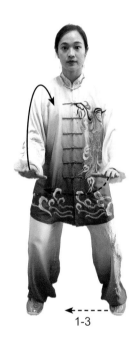

1-3

2. 兩臂平舉 Raise arms to shoulder level

兩臂向前、向上慢慢平舉，與肩同高，力點在兩手前臂，目視前方。 （圖 1-2）

Raise arms slowly forwards and upwards to shoulder level, the point of force at both forearms, look straight ahead.(Fig. 1-2)

3. 屈膝下按 Bend knees and press hands downward

屈膝鬆肩鬆胯，兩手向下按掌，微微坐腕，力達掌根，目視前下方。 （圖 1-3）

Bend knees, relax shoulders, relax hips, press down both arms, bend the wrists slightly, the point of force at bases of the palms, look ahead downwards. (Fig. 1-3)

第二式 左右左野馬分鬃
Parting the Wild Horse's Mane on Both Sides

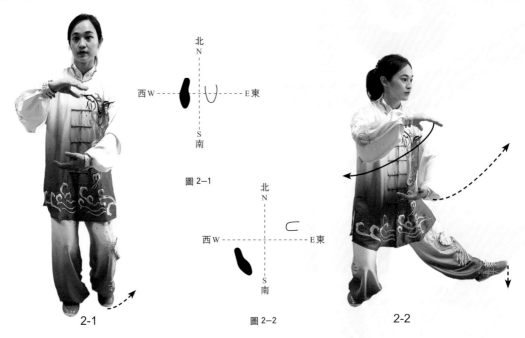

北 N

西 W ———————— E 東

S 南

圖 2-1

北 N

西 W ———————— E 東

S 南

圖 2-2

2-1

2-2

1、 丁步抱球 T-step and hold ball

重心移至右腳，兩掌在右胸前合抱，右手屈臂收在胸前，掌心向下，左手劃弧收至右胯前，掌心向上，同時左腳收到右腳內側，腳尖點地，目視右手。（圖 2-1）

Move the center of gravity to the right foot, both palms facing each other in front of the right chest, bend the right arm in front of the chest, palm down, left hand to the right hip, palm up,keep the left foot in T-step inside of the right foot, look at the right hand. (Fig. 2-1)

2、 左轉上步 Turn left and step forward

身體左轉，提左腳向左前方上步，腳跟先著地，目視左前方。 （圖 2-2）

Turn left, step left foot forward to the left with heel step on the ground,and keep looking to the left. (Fig. 2-2)

第二式 左右左野馬分鬃

Parting the Wild Horse's Mane on Both Sides

2

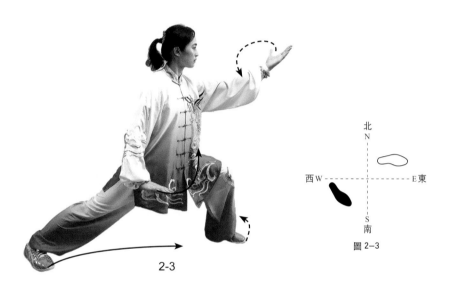

北
N

西 W — — — — — — — E 東

S
南

圖 2-3

2-3

3、弓步分掌 Bow step and part out the palms

身體繼續左轉，重心左移，左腳前弓，右腳後蹬，成左弓步，同時兩手上下斜分，左手腕與肩平，掌心斜向上，右手收至右胯旁，掌心向下，目視左手。（圖 2-3）

Continue to turn left, the center of gravity moves to the left, make a left bow step, at the same time, open both arms in an oblique direction, left wrist to shoulder level, palm oblique upwards, press right hand down to the right hip, palm down, look at the left hand. (Fig. 2-3)

第二式 左右左野馬分鬃

Parting the Wild Horse's Mane on Both Sides

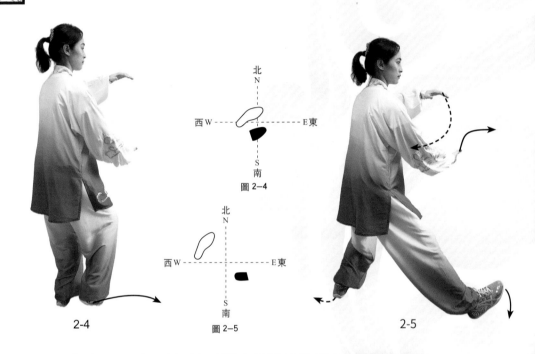

圖 2-4

圖 2-5

2-4

2-5

4、撇腳抱球 Twist the left toes and hold the ball

身體微左轉，重心移至左腳，右腳收至左腳內側，同時右手外旋翻掌，收至左胯前，掌心向上，兩掌相抱，目視左手。（圖 2-4）

Turn left slightly, the center of gravity moves to the left foot, step right foot to the inside of the left foot, at the same time, right hand rotates externally and rest in front of the left hip, palm upwards, both palms face each another, look at the left hand. (Fig. 2-4)

5. 右轉上步 Turn right and step forward

身體右轉，提右腳向右前方上步，腳跟先著地，目視右前方。（圖 2-5）

Turn right, step right foot forward to the right, with heel touching the ground, look to the right.(Fig. 2-5)

第二式 左右左野馬分鬃
Parting the Wild Horse's Mane on Both Sides

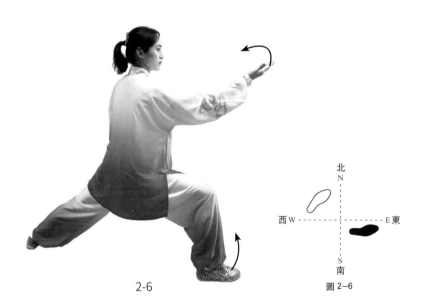

2-6

北
N

西W — — — — E東

S
南

圖 2-6

6、弓步分掌 Bow step and open palms

身體繼續右轉，右腳前弓，左腳後蹬，成右弓步，同時兩手上下斜分，右手腕與肩平，掌心斜向上，左手收至左胯旁，掌心向下，目視右手。（圖 2-6）

Continue to turn right, the center of gravity moves to the right, make a right bow step, at the same time, open both arms in an oblique direction, right wrist to shoulder level, palm oblique upwards, press left hand down to the left hip, palm down, look at the right hand.(Fig. 2-6)

2 第二式 左右左野馬分鬃

Parting the Wild Horse's Mane on Both Sides

7、撤腳抱球 Twist the left toes and hold the ball

重心移至右腳，兩掌在右胸前合抱，右手屈臂收在胸前，掌心向下，左手劃弧收至右胯前，掌心向上，同時左腳收到右腳內側，腳尖點地，目視右手。（圖 2-7）

Turn right slightly, the center of gravity moves to the right foot, step left foot to the inside of the right foot, at the same time, left hand rotates externally and rest in front of the right hip, palm upwards, both palms face each another, look at the right hand. (Fig. 2-7)

8、左轉上步 Turn left and step forward

身體左轉，提左腳向左前方上步，腳跟先著地，目視左前方。（圖 2-8）

Turn left, step left foot forward to the left, with heel touching the ground,keep looking to the left. (Fig. 2-8)

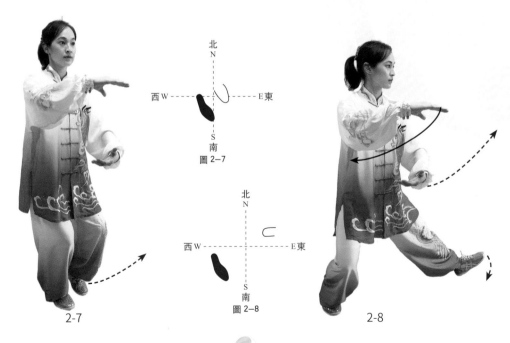

2-7

2-8

第二式 左右左野馬分鬃
Parting the Wild Horse's Mane on Both Sides

2

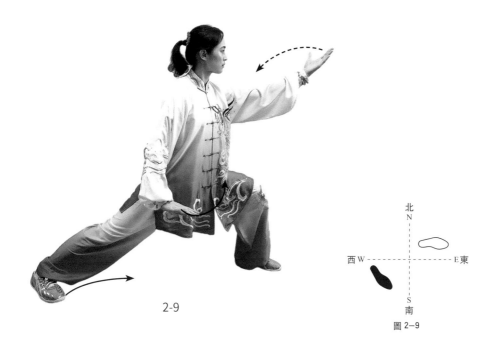

2-9

圖 2—9

北 N
西 W — — — E 東
S 南

9、弓步分掌 Bow step open palms

身體繼續左轉，重心左移，左腳前弓，右腳後蹬，成左弓步，同時兩手上下斜分，左手腕與肩平，掌心斜向上，右手收至右胯旁，掌心向下，目視左手。（圖 2-9）

Continue to turn left, the center of gravity moves to the left, make a left bow step, at the same time, open both arms in an oblique direction, left wrist to shoulder level, palm oblique upwards, press right hand down to the right hip, palm down, look at the left hand. (Fig. 2-9)

第三式 白鶴亮翅
White Crane Spreads its Wings

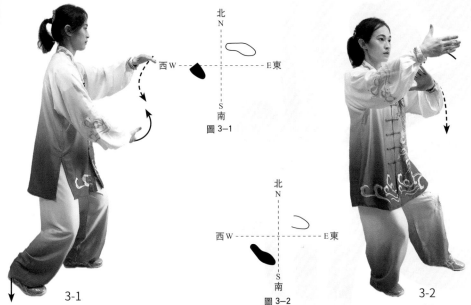

3-1

圖 3-1

圖 3-2

3-2

1、跟腳抱球 Right foot half-step forward and hold ball

身體左轉，右腳收至左腳右後側，腳尖著地，同時兩掌相抱至左胸前，左掌在上，掌心向下，右掌在下，掌心向上，目視左手。（圖 3-1）

Turn left, move the right foot half-step forward, with the toes on the ground, while the two palms face one another in front of the left chest, left hand is on the top, with left palm facing down, right hand is under the left hand with right palm facing upward, look at the left hand. (Fig. 3-1)

2、坐腿合舉 Sit back and raise palms

身體右轉，重心右移，右腳踩實，左腳腳跟上提，同時兩臂相合向右、向上掤舉，目視右手。（圖 3-2）

Turn right, the center of gravity moves to the right, the right foot stands firmly on the ground, the left heel lifts slightly upwards, at the same time, keep both palms in oblique direction, lift right hand upwards, look at the right hand. (Fig. 3-2)

第三式 白鶴亮翅

3

White Crane Spreads its Wings

3、虛步分掌 Empty step and open palms

身體左轉，左腳輕輕提起再以腳掌點地，成虛步，同時兩手上下斜分，右手至頭部右前側，掌心向左後方，左手落於左胯前，掌心向下，目視前方。（圖 3-3）

Turn left,move the left foot gently forwards with the toes on the ground to form an empty left-foot stance,at the same time,both palms open up and down in an oblique direction, right hand to the right side and in front of the forehead, palm facing left, left hand to the left hip, palm down and look straight ahead. (Fig. 3-3)

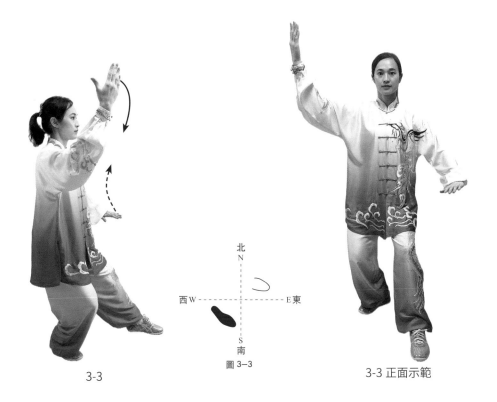

北
N

西W——————E東

S
南

圖 3-3

3-3

3-3 正面示範

4 第四式 左右左摟膝拗步

Brush Knee and Twist Step on Both Sides

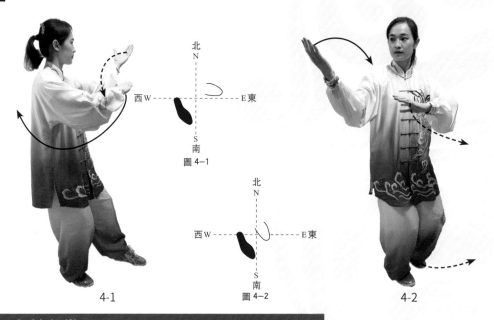

4-1 圖 4-1 圖 4-2 4-2

1、左轉翻掌 Turn left and turn over palm

身體左轉，右手向左、向下劃弧翻掌下落，掌心向下，左掌外旋，掌心向上，目視左手。（圖 4-1）

Turn the body leftward, the right hand moves to the left with the right palm facing downwards, left palm rotates externally, palm facing upwards, look at the left hand. (Fig. 4-1)

2、右轉舉掌 Turn right and raise right palm

身體右轉，左掌內旋 掌心向下，右掌外旋，掌心向上，同時左腳收至右腳內側，腳尖点地，目視右手。 （圖 4-2）

Turn the body rightward, left palm rotates internally, palm facing downwards, raise right palm rotates externally with the palm facing upwards, at the same time, let the left toes points to the ground, look at the right hand. (Fig. 4-2)

第四式 左右左摟膝拗步
Brush Knee and Twist Step on Both Sides

3、上步屈肘 Step forward and bend elbow

身體左轉，左腳向左前方上步，同時右手屈肘收至右耳側，掌心斜向前，左手下落在胸前，掌心向下，目視前方。（圖 4-3）

Turn left, step the left foot to the front left, while the right hand bends at the elbow to the side of the right ear, the palm oblique forwards, the left hand falls in front of the chest, the palm is down, look straight ahead. (Fig. 4-3)

4、弓步摟推 Bow step and push palm

身體繼續左轉，左腳前弓，右腳後蹬，成左弓步，同時右掌經右耳側向前推出，腕與肩平，力達掌根，左掌經左膝前摟至左胯旁，掌心向下，目視右手。（圖 4-4）

Continue to turn left, left foot bow step forward, right foot pushes back into left bow stance, while the right palm moves forward alongside the right ear, wrist and shoulder flat, with force at the palm root, brush left palm from the left knee to the left hip, palm down, look at the right hand. (Fig. 4-4)

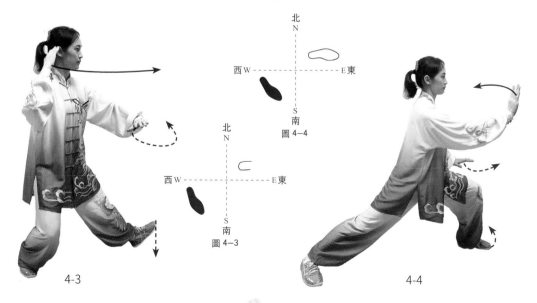

4-3

4-4

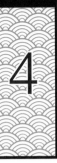

第四式 左右左摟膝拗步

Brush Knee and Twist Step
on Both Sides

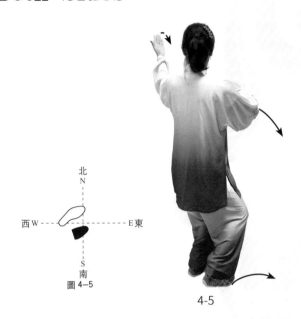

北
N

西 W — — — — — — — E 東

S
南
圖 4-5

4-5

5、撇腳舉掌 Twist the left toes outwards and raise left palm

身體左轉，重心左移，左手劃弧上舉至左肩後側，腕與肩平，掌心斜向上，右手收至左胸前，掌心向下，同時右腳收至左腳內側，腳尖著地，目視左手。（圖 4-5）

Turn the body leftward, the center of gravity moves to the left foot, the left hand is raised towards to the left shoulder, with wrist and shoulder at same level, the palm facing upwards in an oblique direction, the right hand comes to the left chest, with the right palm facing downwards, at the same time, let the left toes points to the ground, look at the left hand. (Fig. 4-5)

第四式 左右左摟膝拗步

Brush Knee and Twist Step on Both Sides

6、上步屈肘 Step forward and bend left elbow

身體右轉，右腳向右前方上步，同時左手屈肘收至左耳側，掌心斜向前，右手下落在胸前，掌心向下，目視右腳。（圖 4-6）

Turn the body leftward, step forward the right foot to the front right, at the same time, the left hand bends the elbow to the left,the left palm moves forward in oblique direction , the right palm hand falls down in front of the chest,look straight ahead.(Fig. 4-6)

7、弓步摟推 Bow step and push palm

身體繼續右轉，右腳前弓，左腳後蹬，成右弓步，同時左掌經左耳側向前推出，腕與肩平，力達掌根，右掌經右膝前摟至右胯旁，掌心向下，目視左手。（圖 4-7）

Continue to turn the body rightward, the center of gravity moves to the right,make a right bow step, at the same time, the left palm moves forward, with wrist and shoulder at same level, with force pointing at the root of the palm , brush right palm from the right knee to the right hip, palm facing down, look at the left hand.(Fig. 4-7)

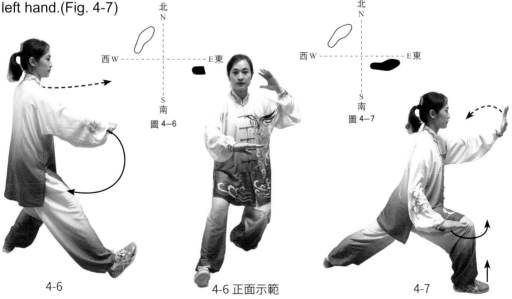

北
N

西 W — — — — — — E 東

S
南

圖 4—6

北
N

西 W — — — — — — E 東

S
南

圖 4—7

4-6 4-6 正面示範 4-7

4

第四式 左右左摟膝拗步
Brush Knee and Twist Step on Both Sides

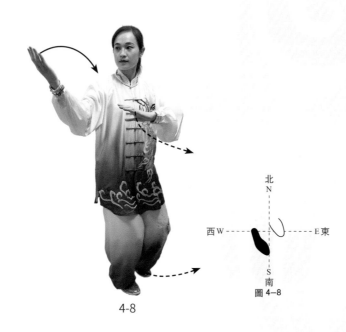

4-8

北
N

西 W ---------- E 東

S
南
圖 4-8

8、撇腳舉掌 Twist the right toes outwards and raise right palm

身體右轉，重心右移，右手劃弧上舉至右肩後側，腕與肩平，掌心斜向上，左手收至右胸前，掌心向下，同時左腳收至右腳內側，腳尖著地，目視右手。 （圖4-8）

Turn the body rightward, the center of gravity moves to the right foot, the right hand is raised towards to the right shoulder, with wrist and shoulder at same level, the palm facing upwards in an oblique direction, the left hand comes to the right chest, with the left palm facing downwards, at the same time, let the right toes points to the ground, look at the right hand. (Fig. 4-8)

第四式 左右左摟膝拗步
Brush Knee and Twist Step
on Both Sides

9、上步屈肘 Step forward and bend right elbow

身體左轉，左腳向左前方上步，同時右手屈肘收至右耳側，掌心斜向前，左手下落在胸前，掌心向下，目視前方。（圖 4-9）

Turn the body leftward, step forward the left foot to the front left, at the same time,the right hand bends the elbow to the right,the right palm moves forward in oblique direction , the left palm hand falls down in front of the chest,look straight ahead. (Fig. 4-9)

10、弓步摟推 Bow step and push palm

身體繼續左轉，左腳前弓，右腳後蹬，成左弓步，同時右掌經右耳側向前推出，腕與肩平，力達掌根，左掌經左膝前摟至左胯旁，掌心向下，目視右手。（圖 4-10）

Continue to turn the body leftward, the center of gravity moves to the left,make a left bow step, at the same time, the right palm moves forward, with wrist and shoulder at same level, with force pointing at the root of the palm , brush left palm from the left knee to the left hip, palm facing down, look at the right hand. (Fig. 4-10)

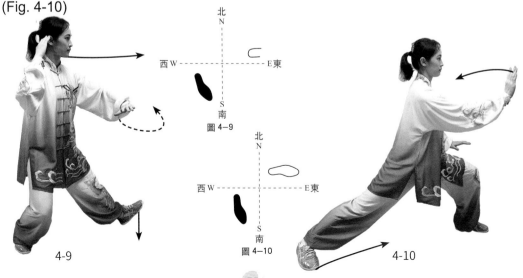

4-9

圖 4—9

圖 4—10

4-10

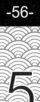

5

第五式 手揮琵琶
Play the Lute

5-1

5-2

1、跟步擺掌 Right foot half-step forward and swing palms

身體左轉，右腳收至左腳右後側，腳尖著地，同時右手向左平擺，掌心向上，左掌隨轉腰向左移至左胯旁，掌心向下，目視右手。（圖 5-1）

Turn the body leftward, move the right foot half-step forward, with the toes on the ground, at the same time, swing the right hand to the left, palm upwards, the left palm moves to the left hip with the turn waist, palm downwards, look at the right hand. (Fig. 5-1)

2、右轉帶臂 Turn right and move arms

身體右轉，重心右移，同時右掌內旋收至右胯旁，掌心向下，左臂向右平帶，掌心斜向下，目視左手。（圖 5-2）

Turn the body rightward,, the center of gravity moves to the right, at the same time, the right palm rotates internally to the right hip, palm downwards, the left arm remains level while moving to the right, palm oblique downwards, look at the left hand. (Fig. 5-2)

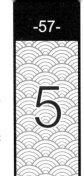

第五式 手揮琵琶

Play the Lute

3、虛步合臂 Left empty step and bring arms together

身體微左轉，左腳提起再以腳跟點地，成左虛步，同時兩臂外旋，右掌在左肘下側，掌心向左，左掌在上，腕與肩平，掌心向右，目視左手。（圖 5-3）

Continue to turn the body left slightly, lift left foot and then heel on the ground, make an left empty step, at the same time, both arms rotate externally, right palm rests beside the lower side of the left elbow, right palm facing left, left palm facing right on top, with wrist and shoulder at same level, look at the left hand. (Fig. 5-3)

5-3

6 第六式 右左右左倒卷肱
Curve Back Arms On Both Sides

1、右轉舉掌 Turn right and raise palm

身體右轉，右掌外旋向右、向後、向上劃弧至右肩後側，掌心向上，目視右手。（圖6-1）

Turn the body rightward, the right palm rotates externally to the right and backwards, then upwards in an arc to the rear side of the right shoulder, palm facing upwards, look at the right hand. (Fig. 6-1)

2、撤步翻掌 Step backward and turn your left palm

身體左轉，提左腳經右腳內側向左後方撤步，腳尖點地，同時右臂屈肘收至右耳側，掌心斜向前，左掌外旋翻掌，掌心向上，目視左手。（圖6-2）

Turn the body leftward, lift left foot backward, point the toes to the ground, at the same time, the right arm bends the elbow to the side of the right, palm oblique forward, left palm rotates externally, palm facing upwards, look at the left hand. (Fig. 6-2)

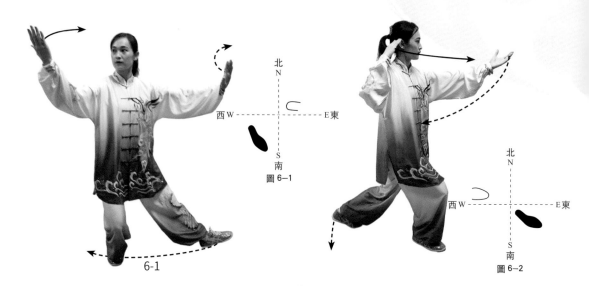

圖 6-1

6-1

圖 6-2

第六式 右左右左倒卷肱
Curve Back Arms On Both Sides

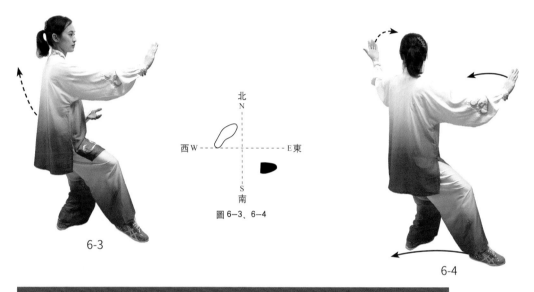

圖 6-3、6-4

6-3

6-4

3、虚步推掌 Right empty step and push right palm

身體繼續左轉，重心左移，右腳跟提起變右虛步，同時右掌經右耳側向前推出，力達掌根，腕與肩平，左掌回收至左腰側，掌心向上，目視右手。（圖 6-3）

Turn the body leftward, the center of gravity moves to the left, make a right empty step, at the same time, the right palm moves forward, wrist and shoulder at same level, with force pointing at the root of the palm ,move the left palm to the left waist, palm facing upwards, look at the right hand. (Fig. 6-3)

4、左轉舉掌 Turn the body left and raise palm

身體左轉，左掌外旋向左、向後、向上劃弧至左肩後側，掌心向上，目視左手。（圖 6-4）

Turn the body leftward, the left palm rotates externally to the left and backwards, then upwards in an arc to the rear side of the left shoulder, palm facing upwards, look at the left hand. (Fig. 6-4).

第六式 右左右左倒卷肱
Curve Back Arms On Both Sides

5、撤步翻掌 Step backward and turn your right palm

身體右轉，提右腳經左腳內側向右後方撤步，腳尖點地，同時左臂屈肘收至左耳側，掌心斜向前，右掌外旋翻掌，掌心向上，目視右手。（圖 6-5）

Turn the body rightward, lift right foot backward, point the toes to the ground, at the same time, the left arm bends the elbow to the side of the left, palm oblique forward, right palm rotates externally, palm facing upwards, look at the right hand. (Fig. 6-5)

6、虛步推掌 Left empty step and push left palm

身體繼續右轉，重心右移，左腳跟提起變左虛步，同時左掌經左耳側向前推出，力達掌根，腕與肩平，右掌回收至右腰側，掌心向上，目視左手。（圖 6-6）

Turn the body rightward, the center of gravity moves to the right, make a left empty step, at the same time, the left palm moves forward, wrist and shoulder at same level, with force pointing at the root of the palm ,move the right palm to the right waist, palm facing upwards, look at the left hand.(Fig. 6-6)

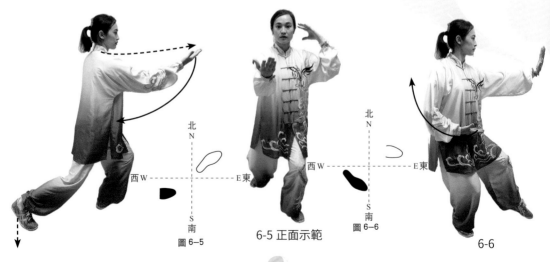

圖 6-5

6-5 正面示範

圖 6-6

6-6

第六式 右左右左倒卷肱
Curve Back Arms On Both Sides

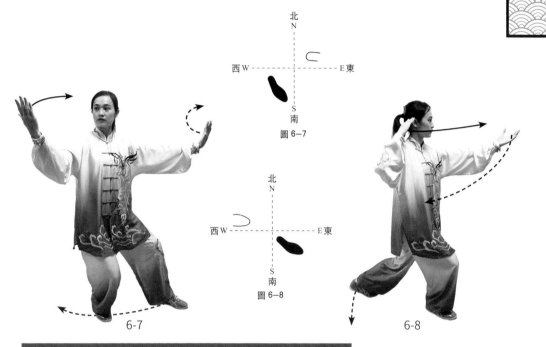

北N

西W --------- E東

S
南
圖 6-7

北N

西W --------- E東

S
南
圖 6-8

6-7

6-8

7、右轉舉掌 Turn right and raise palm

身體右轉，右掌外旋向右、向後、向上劃弧至右肩後側，掌心向上，目視右手。（圖6-7）

Turn the body rightward, the right palm rotates externally to the right and backwards, then upwards in an arc to the rear side of the right shoulder, palm facing upwards, look at the right hand. (Fig. 6-7)

8、撤步翻掌 Step backward and turn your left palm

身體左轉，提左腳經右腳內側向左後方撤步，腳尖點地，同時右臂屈肘收至右耳側，掌心斜向前，左掌外旋翻掌，掌心向上，目視左手。（圖6-8）

Turn the body leftward, lift left foot backward, point the toes to the ground, at the same time, the right arm bends the elbow to the side of the right, palm oblique forward, left palm rotates externally, palm facing upwards, look at the left hand. (Fig. 6-8)

第六式 右左右左倒卷肱
Curve Back Arms On Both Sides

9、虛步推掌 Right empty step and push right palm

身體繼續左轉，重心左移，右腳跟提起變右虛步，同時右掌經右耳側向前推出，力達掌根，腕與肩平，左掌回收至左腰側，掌心向上，目視右手。（圖 6-9）

Continue to turn left, the center of gravity moves left, the right heel lifts and change into right empty stance, at the same time, the right palm pushes forward alongside the right ear, the force reaches the palm root, the wrist and the shoulder level, retract the left palm to the left waist, palm upwards, look at the right hand. (Fig. 6-9)

10、左轉舉掌 Turn the body left and raise palm

身體左轉，左掌外旋向左、向後、向上劃弧至左肩後側，掌心向上，目視左手。（圖 6-10）

Turn the body leftward, the left palm rotates externally to the left and backwards, then upwards in an arc to the rear side of the left shoulder, palm facing upwards, look at the left hand. (Fig. 6-10).

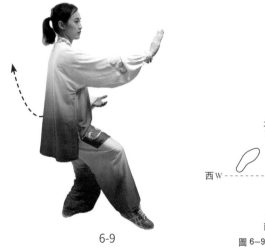

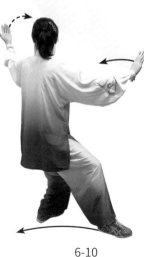

6-9

圖 6-9、6-10

6-10

第六式 右左右左倒卷肱
Curve Back Arms On Both Sides

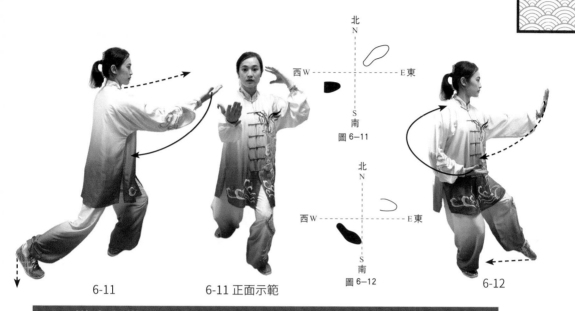

6-11　　　　　6-11 正面示範　　　　　6-12

11、撤步翻掌 Step backward and turn your right palm

身體右轉，提右腳經左腳內側向右後方撤步，腳尖點地，同時左臂屈肘收至左耳側，掌心斜向前，右掌外旋翻掌，掌心向上，目視右手。（圖 6-11）

Turn the body rightward, lift right foot backward, point the toes to the ground, at the same time, the left arm bends the elbow to the side of the left, palm oblique forward, right palm rotates externally, palm facing upwards, look at the right hand. (Fig. 6-11)

12、虛步推掌 Left empty step and push left palm

身體繼續右轉，重心右移，左腳跟提起變左虛步，同時左掌經左耳側向前推出，力達掌根，腕與肩平，右掌回收至右腰側，掌心向上，目視左手。（圖 6-12）

Turn the body rightward, the center of gravity moves to the right, make a left empty step, at the same time, the left palm moves forward, wrist and shoulder at same level, with force pointing at the root of the palm ,move the right palm to the right waist, palm facing upwards, look at the left hand. . (Fig. 6-12)

7

第七式 左攬雀尾（左掤捋擠按）
Left Ward-off, Pull, Press and Push

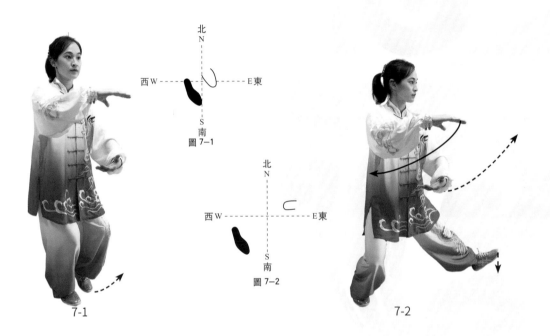

圖 7-1

圖 7-2

7-1

7-2

1、丁步抱球 Left T-step and hold ball

重心移至右腳，兩掌在右胸前合抱，右手屈臂收在胸前，掌心向下，左手劃弧收至右胯前，掌心向上，同時左腳收到右腳內側，腳尖點地，目視右手。（圖 7-1）

Move the center of gravity to the right foot, both palms facing each other in front of the right chest, bend the right arm in front of the chest, palm down, left hand to the right hip, palm up, keep the left foot in T-step inside of the right foot, look at the right hand. (Fig. 7-1)

2、左轉上步 Turn the body left and step forward

身體左轉，提左腳向左前方上步，腳跟先著地，目視左前方。（圖 7-2）

Turn the body leftward, step left foot forward to the left with heel step on the ground, and keep looking to the left. (Fig. 7-2)

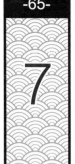

第七式 左攬雀尾（左掤捋擠按）
Left Ward—off,Pull,Press and Push

3、弓步左掤 Bow step and left ward-off

身體繼續左轉，左腳前弓，右腳後蹬，成左弓步，同時左臂向前掤出，腕與肩平，掌心向內，右手下落至右胯旁，掌心向下，目視前方。（圖 7-3）

Continue to turn the body leftward, the center of gravity moves to the left,make a left bow step, at the same time, the left arm ward-off outward and forward, wrist and shoulder at same level, palm facing inwards, right hand with palm facing downwards to the right hip, look straight ahead. (Fig. 7-3)

4、左轉伸掌 Turn the body leftward and turn both arms forward

身體繼續左轉，兩掌隨轉腰向左前伸，左掌內旋，掌心向下，右掌外旋，掌心向上，目視左手。（圖 7-4）

Turn the body leftward, both arms extend forward to the left side, left palm facing downward, right palm facing upwards, look at the left hand. (Fig. 7-4)

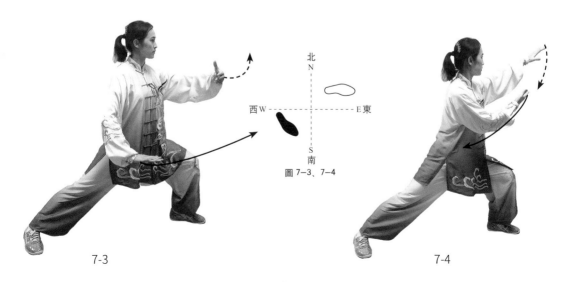

北
N

西 W ————————— E 東

S
南
圖 7—3、7—4

7-3

7-4

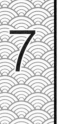

7

第七式 左攬雀尾（左掤捋擠按）
Left Ward-off, Pull, Press and Push

5、右轉下捋 Turn the body right and rollback downwards

身體右轉，重心右移，兩手向右、向下捋至腹前，左掌掌心向下，右掌掌心向上，目視左手。（圖 7-5）

Turn the body rightward, the center of gravity moves to the right, both hands rollback downwards to the right, in front of the abdomen, left palm facing downwards, right palm facing upwards, look at the left hand. (Fig. 7-5)

6、右轉翻掌 Turn right and turn over palms

身體繼續右轉，右手劃弧至右肩後側，腕與肩平，掌心向上，左手屈臂收至胸前，掌心向內，目視右手。（圖 7-6）

Continue to turn the body rightward, curl back the right hand to the right shoulder, wrist and shoulder at same level, palm facing upwards, bends the left arm to the chest, palm inwards, look at the right hand. (Fig. 7-6)

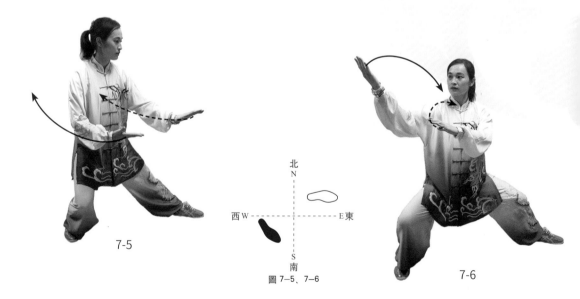

7-5

北
N

西 W - - - - - - - - - - - E 東

S
南
圖 7-5、7-6

7-6

第七式 左攬雀尾（左掤捋擠按）
Left Ward-off, Pull, Press and Push

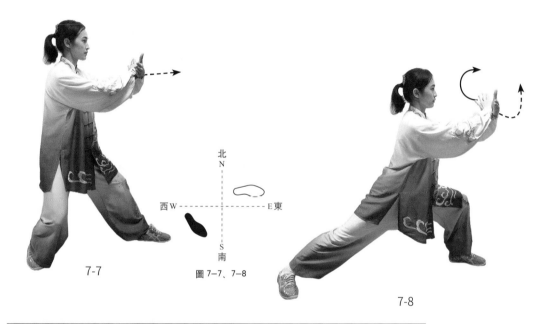

7-7

圖 7-7、7-8

北
N

西W —— —— E東

S
南

7-8

7、左轉搭腕 Turns the body left and cross wrists

身體左轉，右臂屈肘回收搭於左手腕內側，掌心相對，目視前方。（圖 7-7）

Turn the body leftward, bends the right elbow and put right wrist on the left wrist, palms facing each another, look straight ahead. (Fig. 7-7)

8、弓步前擠 Bow step and push forward

身體繼續左轉，左腳前弓，右腳後蹬，成左弓步，同時兩臂圓撐向前擠出，力達左前臂外側，目視前方。（圖 7-8）

Continue to turn the body leftward, the center of gravity moves to the left, make a left bow step, at the same time, both arms pushing forward, the force should reach the outside of the left forearm, look straight ahead. (Fig. 7-8)

7

第七式 左攬雀尾 （左掤捋擠按）
Left Ward—off,Pull,Press and Push

9、抹掌平分 Spread the palms apart

兩掌平抹分開，肩高肩寬，兩掌掌心均向下，目視前方。 （圖 7-9）

Spread the palms apart to the height and width of the shoulders level, both palms facing downwards, look straight ahead. (Fig. 7-9)

10、後坐下按 Sit back and press downwards

身體微右轉，重心右移，兩掌隨後坐向後弧線回收再下按，掌心向下，目視前方。 （圖 7-10）

Turn the body slightly rightward, the center of gravity moves to the right, sit back, both palms then press downward, look straight ahead. (Fig. 7-10)

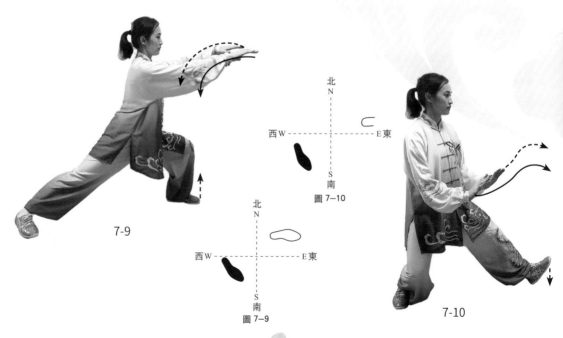

7-9

圖 7-10

圖 7-9

7-10

第七式 左攬雀尾（左掤捋擠按）
Left Ward−off, Pull, Press and Push

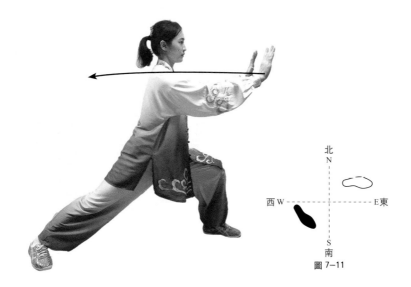

北
N

西 W — — — — — — — — E 東

S
南
圖 7−11

11、弓步前按 Bow step and press forward

身體微左轉，左腳前弓，右腳後蹬，成左弓步，同時兩掌自下向上再向前按出，腕於肩平，力達掌根，目視前方。（圖 7-11）

Turn the body slightly leftward, the center of gravity moves to the left, make a left bow step, at the same time, both palms pressing upward and forward, wrist and shoulder at same level, the force reaches the roots of both palms, look straight ahead. (Fig. 7-11)

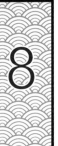

第八式 右攬雀尾（右掤挒擠按）

Right Ward−off, Pull, Press and Push

8-1

圖 8−1

圖 8−2

8-2

1、右轉分掌 Turns right and open palm

身體右轉，重心右移，左腳上翹微內扣，右臂向右平移分開，目視右手。（圖 8-1）

Turn the whole body rightward, the center of gravity moves to the right, the left foot turns slightly to the right, the right arm moves to the right to form an arc shape, look at the right hand. (Fig. 8-1)

2、丁步抱球 Right T-step and hold ball

重心移至左腳，兩掌在左胸前合抱，左手屈臂收在胸前，掌心向下，右手劃弧收至左胯前，掌心向上，同時右腳收到左腳內側，腳尖點地，目視左手。（圖 8-2）

Move the center of gravity to the left foot, both palms facing each other in front of the left chest, bend the left arm in front of the chest, palm facing down, right hand to the left hip, palm up,keep the right foot in T-step inside of the left foot, look at the left hand. (Fig. 8-2)

第八式 右攬雀尾（右掤捋擠按）
Right Ward-off, Pull, Press and Push

3、右轉上步 Turn the body right and step forward

身體右轉，提右腳向右前方上步，腳跟先著地，目視右前方。（圖 8-3）

Turn the body rightward, step right foot forward to the right with heel step on the ground, and keep looking to the right. (Fig. 8-3)

4、弓步右掤 Bow step and Right ward-off

身體繼續右轉，右腳前弓，左腳後蹬，成右弓步，同時右臂向前掤出，腕與肩平，掌心向內，左手下落至左胯旁，掌心向下，目視前方。（圖 8-4）

Continue to turn the body rightward, the center of gravity moves to the right, make a right bow step, at the same time, the right arm ward-off outward and forward, wrist and shoulder at same level, palm facing inwards, left hand with palm facing downwards to the left hip, look straight ahead. (Fig. 8-4)

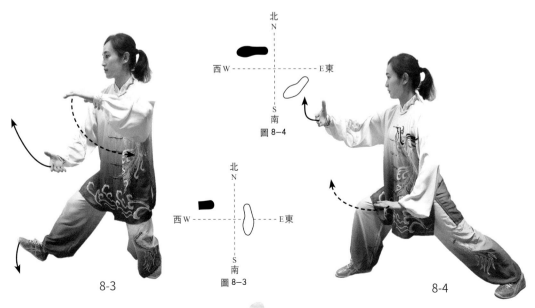

8-3

圖 8-3

圖 8-4

8-4

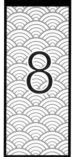

第八式 右攬雀尾（右掤捋擠按）
Right Ward—off, Pull, Press and Push

5、右轉伸掌 Turn the body rightward and turn both arms forward

身體繼續右轉，兩掌隨轉腰向右前伸，右掌內旋，掌心向下，左掌外旋，掌心向上，目視右手。（圖 8-5）

Turn the body rightward, both arms extend forward to the right side, right palm facing downward, left palm facing upwards, look at the right hand. (Fig. 8-5)

6、左轉下捋 Turn the body left and rollback downwards

身體左轉，重心左移，兩手向左、向下捋至腹前，右掌掌心向下，左掌掌心向上，目視右手。（圖 8-6）

Turn the body leftward, the center of gravity moves to the left, both hands rollback downwards to the left, in front of the abdomen, right palm facing downwards, left palm facing upwards, look at the right hand. (Fig. 8-6)

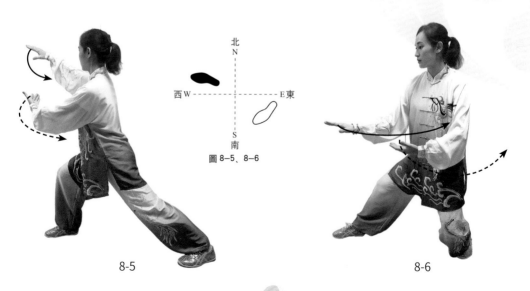

北
N

西 W ———————————— E 東

S
南

圖 8-5、8-6

8-5 8-6

第八式 右攬雀尾（右掤捋擠按）
Right Ward—off,Pull,Press and Push

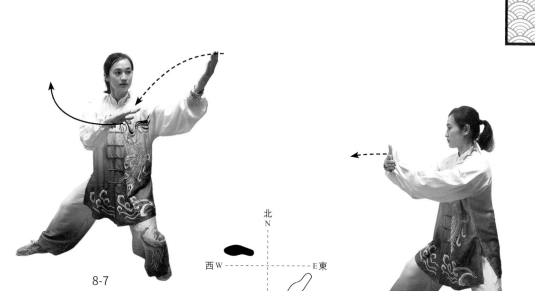

8-7

北
N

西 W —————————— E 東

S
南

圖 8-7、8-8

8-8

7、左轉翻掌 Turn left and turn over palms

身體繼續左轉，左手劃弧至左肩後側，腕與肩平，掌心向上，右手屈臂收至胸前，掌心向內，目視左手。 （圖 8-7）

Continue to turn the body leftward, curl back the left hand to the left shoulder, wrist and shoulder at same level, palm facing upwards, bends the right arm to the chest, palm inwards, look at the left hand. (Fig. 8-7)

8、右轉搭腕 Turns the body right and cross wrists

身體右轉，左臂屈肘回收搭於右手腕內側，掌心相對，目視前方。 （圖 8-8）

Turn the body rightward, bends the left elbow and put left wrist on the right wrist, palms facing each another, look straight ahead. (Fig. 8-8)

第八式 右攬雀尾（右掤捋擠按）
Right Ward−off, Pull, Press and Push

9、弓步前擠 Bow step and push forward

身體繼續右轉，右腳前弓，左腳後蹬，成右弓步，同時兩臂圓撐向前擠出，力達右前臂外側，目視前方。（圖 8-9）

Continue to turn the body rightward, the center of gravity moves to the right, make a right bow step, at the same time, both arms pushing forward, the force should reach the outside of the right forearm, look straight ahead. (Fig. 8-9)

10、抹掌平分 Spread the palms apart

兩掌平抹分開，肩高肩寬，兩掌掌心均向下，目視前方。（圖 8-10）

Spread the palms apart to the height and width of the shoulders level, both palms facing downwards, look straight ahead. (Fig. 8-10)

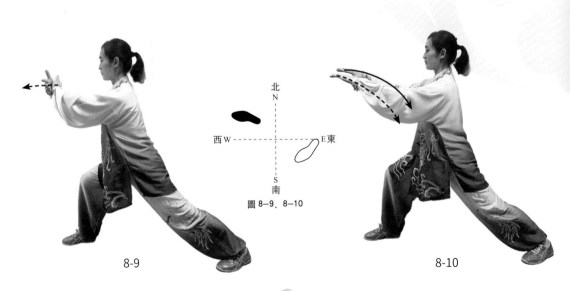

圖 8−9、8−10

8-9　　　　　　　　　　　　　8-10

第八式 右攬雀尾（右掤捋擠按）
Right Ward-off, Pull, Press and Push

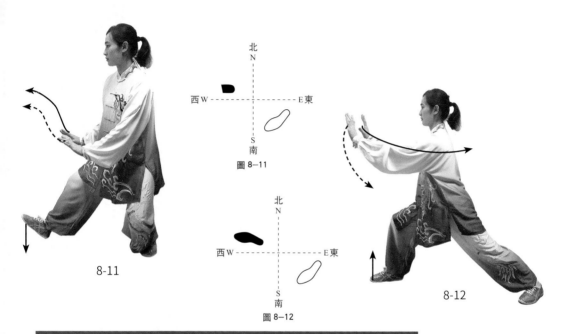

圖 8-11

圖 8-12

8-11

8-12

11、後坐下按 Sit back and press downwards

身體微左轉，重心左移，兩掌隨後坐向後弧線回收再下按，掌心向下，目視前方。（圖 8-11）

Turn the body slightly leftward, the center of gravity moves to the left, sit back, both palms then press downward, look straight ahead. (Fig. 8-11)

12、弓步前按 Bow step and press forward

身體微右轉，右腳前弓，左腳後蹬，成右弓步，同時兩掌自下向上再向前按出，腕於肩平，力達掌根，目視前方。 （圖 8-12）

Turn the body slightly rightward, the center of gravity moves to the right, make a right bow step, at the same time, both palms pressing upward and forward, wrist and shoulder at same level, the force reaches the roots of both palms, look straight ahead. (Fig. 8-12)

9 第九式 左單鞭
Left Single Whip

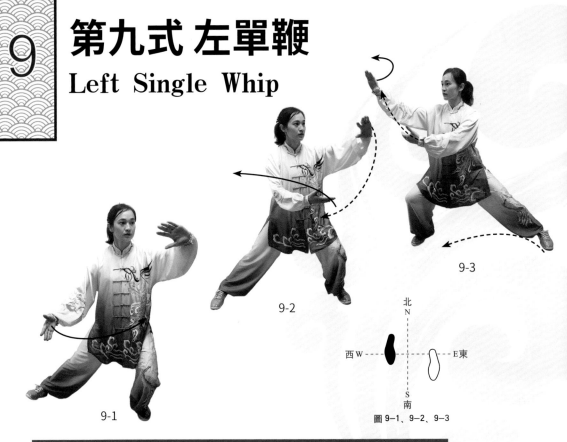

9-3

9-2

9-1

北
N

西W ---- ● ○ ---- E東

S
南

圖 9-1、9-2、9-3

1、左轉雲掌 Turn the body left and cloud palms

身體左轉，重心左移，右腳內扣，同時左手以腰為軸向左雲掌，掌心向外，右手劃弧向左、向下雲掌，掌心向內，目視左手。（圖 9-1、9-2）

Turn the body leftward, the center of gravity moves to the left foot, twist the right toes inward, at the same time, turn the waist to the left, left palm facing outwards, the right palm draws an arc to the left, right palm facing inwards, look at the left hand. (Fig. 9-1、9-2)

2、右轉雲掌 Turn the body right and cloud palms

身體右轉，重心右移，同時右掌劃弧向右、向上雲掌，腕與肩平，左掌劃弧收至腹前，掌心向內，目視右手。（圖 9-3）

Turn the body rightward, the center of gravity moves to the right foot, at the same time, the right palm turns towards the right in an upwards movement, wrist and shoulder at same level, left palm draws an arc to the front of the abdomen, palm facing inward, look at right hand. (Fig. 9-3)

第九式 左單鞭
Left Single Whip

9

3、丁步按掌 Left T-step and press arm

身體右轉，左腳收至右腳內側，腳尖點地，同時右手外翻按掌，力達掌根，腕與肩平，掌心向外，左掌收至右手腕部內側，掌心向內，目視右手。（圖9-4）

Turn the body rightward,let the left toes points to the ground, at the same time, turn the right hand outward, the force reaches the root of the palm,wrist and shoulder at same level, palms facing outwards, turn the left palm to the right wrist, palm facing inwards, look at the right hand. (Fig. 9-4)

4、勾手上步 Hook hand and step forward

身體左轉，右掌變勾手，左手向左平移，掌心向內，同時左腳向左上步，腳跟著地，目視左手。（圖9-5）

Turn the body leftward, the right palm changes into hook hand, the left hand moves towards the left, palm facing inwards, at the same time, the left foot step forward to the left,with the heel pointing to the ground, look at the left hand. (Fig. 9-5)

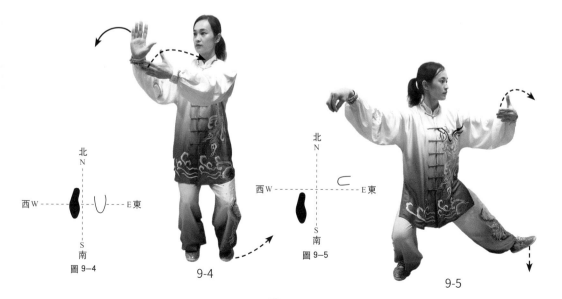

圖9-4

9-4

圖9-5

9-5

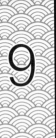

9

第九式 左單鞭
Left Single Whip

5、弓步推掌 Bow step and push palm

身體繼續左轉，左腳前弓，右腳後蹬，成左弓步，同時左手向左、向前翻掌前推，腕與肩平，力達掌根，右手保持勾手不變，目視左手。（圖9-6）

Continue to turn the body leftward, the center of gravity moves to the left,make a left bow step, at the same time, push the left hand to the front, wrist and shoulder at same level, the force reaches the root of the palm, keeps the right hook hand, look at the left hand. (Fig. 9-6)

9-6

北
N

西 W ----------- E 東

S
南

圖 9-6

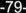

第十式 雲手
Cloud Hands

10-1

10-2

圖 10-1、10-2

圖 10-3

10-3

1、右轉雲掌 Turn right and cloud palms

身體右轉，重心右移，同時左掌劃弧向右、向下雲掌，掌心向內，右勾手變掌，掌心向外，目視右手。（圖 10-1）

Turn the body rightward, the center of gravity moves to the right, at the same time, the left palm draws an arc to the right and downwards, palm facing inwards, release right hook hand to palm, palm facing outwards, look at the right hand. (Fig. 10-1)

2、收腳雲掌 Move right foot inward and cloud palms

身體左轉，右腳收至左腳內側，腳尖點地，同時左手向左雲掌，腕與肩平，掌心向外，右手雲掌至左腰旁，掌心向內，目視左手。（圖 10-2、10-3）

Turn the body leftward,move the right toes inwards pointing to the ground, at the same time, the left hand does the left cloud hand movement, wrist and shoulder at same level, left palm facing outwards, right hand cloud hand to the left side of the waist, palm facing inwards, look at the left hand. (Fig. 10-2、10-3)

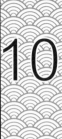

10

第十式 雲手
Cloud Hands

3、開步雲掌 Move left foot outward and cloud palms

身體右轉，左腳向左橫開一步，腳尖點地，同時右手向右雲掌，腕與肩平，掌心向外，左手雲掌至左腰旁，掌心向內，目視右手。（圖 10-4、10-5）

Turn the body rightward, the left foot takes one horizontal step to the left, point the toes to the ground, at the same time,the right hand does the right cloud hand movement,wrist and shoulder at same level, right palm facing outwards, left hand cloud hand to the left waist, palm facing inwards, look at the right hand. (Fig. 10-4、10-5)

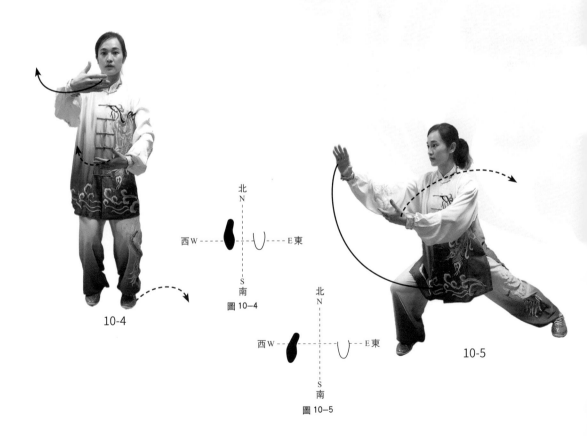

10-4

北
N

西 W ----- ╫ ---- E 東

S
南
圖 10-4

北
N

西 W ----- ╫ ---- E 東

S
南
圖 10-5

10-5

第十式 雲手
Cloud Hands

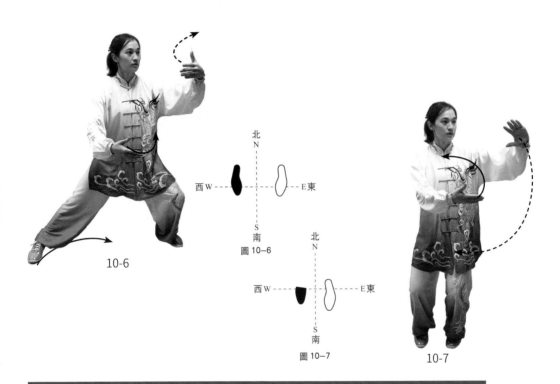

圖 10—6

10-6

圖 10—7

10-7

4、收腳雲掌 Move right foot inward and cloud palms

身體左轉，右腳收至左腳內側，腳尖點地，同時左手向左雲掌，腕與肩平，掌心向外，右手雲掌至左腰旁，掌心向內，目視左手。（圖 10-6、10-7）

Turn the body leftward,move the right toes inwards pointing to the ground, at the same time, the left hand does the left cloud hand movement, wrist and shoulder at same level, left palm facing outwards, right hand cloud hand to the left side of the waist, palm facing inwards, look at the left hand. (Fig. 10-6、10-7)

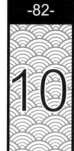

10 第十式 雲手
Cloud Hands

5、開步雲掌 Move left foot outward and cloud palms

身體右轉，左腳向左橫開一步，腳尖點地，同時右手向右雲掌，腕與肩平，掌心向外，左手雲掌至左腰旁，掌心向內，目視右手。（圖 10-8、10-9）

Turn the body rightward, the left foot takes one horizontal step to the left, point the toes to the ground, at the same time,the right hand does the right cloud hand movement,wrist and shoulder at same level, right palm facing outwards, left hand cloud hand to the left waist, palm facing inwards, look at the right hand. (Fig. 10-8、10-9)

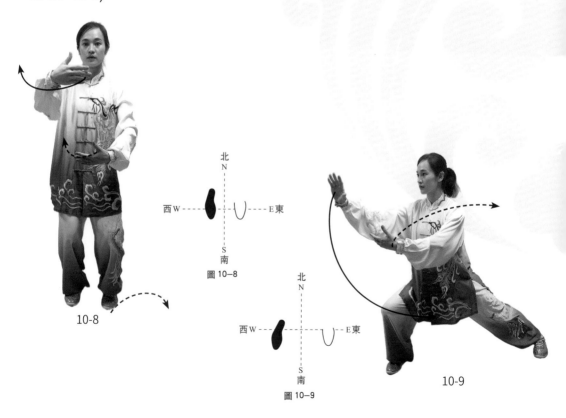

西W —— E東
北N
S南
圖 10—8

10-8

西W —— E東
北N
S南
圖 10—9

10-9

第十式 雲手
Cloud Hands
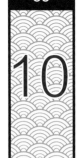

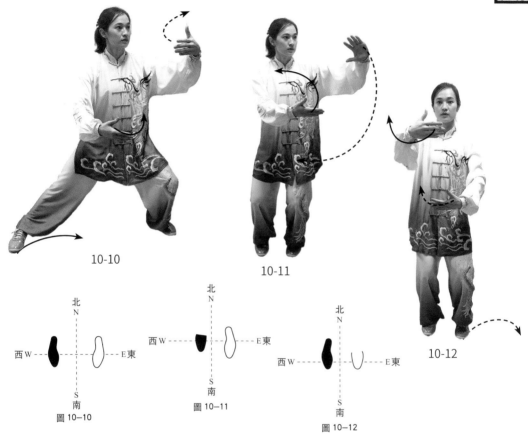

10-10

10-11

10-12

圖 10—10

圖 10—11

圖 10—12

6、收腳雲掌 Move right foot inward and cloud palms

身體左轉，右腳收至左腳內側，腳尖點地，同時左手向左雲掌，腕與肩平，掌心向外，右手雲掌至左腰旁，掌心向內，目視左手。（圖 10-10、10-11、10-12）

Turn the body leftward, move the right toes inwards pointing to the ground, at the same time, the left hand does the left cloud hand movement, wrist and shoulder at same level, left palm facing outwards, right hand cloud hand to the left side of the waist, palm facing inwards, look at the left hand. (Fig. 10-10、10-11、10-12)

11 第十一式 左單鞭
Left Single Whip

1、丁步按掌 Left T-step and press arm

身體右轉，左腳收至右腳內側，腳尖點地，同時右手外翻按掌，力達掌根，腕與肩平，掌心向外，左掌收至右手腕部內側，掌心向內，目視右手。（圖 11-1）

Turn the body rightward,let the left toes points to the ground, at the same time, turn the right hand outward, the force reaches the root of the palm,wrist and shoulder at same level, palms facing outwards, turn the left palm to the right wrist, palm facing inwards, look at the right hand. (Fig. 11-1)

2、勾手上步 Hook hand and step forward

身體左轉，右掌變勾手，左手向左平移，掌心向內，同時左腳向左上步，腳跟著地，目視左手。（圖 11-2）

Turn the body leftward, the right palm changes into hook hand, the left hand moves towards the left, palm facing inwards, at the same time, the left foot step forward to the left,with the heel pointing to the ground, look at the left hand. (Fig. 11-2)

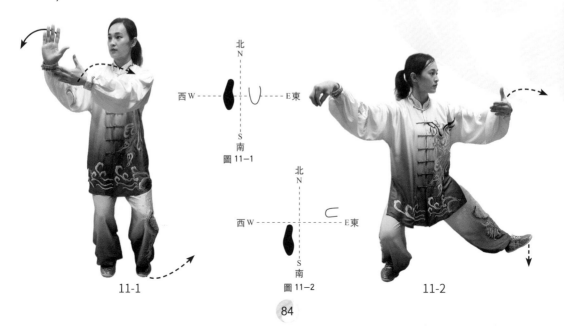

11-1　　　　圖 11-1　　　　圖 11-2　　　　11-2

第十一式 左單鞭
Left Single Whip

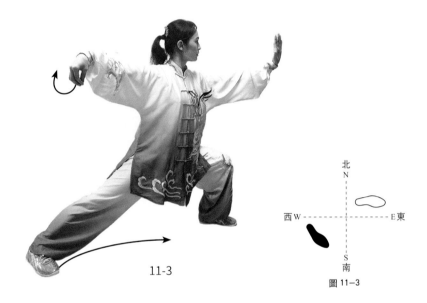

北
N

西 W ------------- E 東

S
南

圖 11-3

11-3

3、弓步推掌 Bow step and push palm

身體繼續左轉，左腳前弓，右腳後蹬，成左弓步，同時左手向左、向前翻掌前推，腕與肩平，力達掌根，右手保持勾手不變，目視左手。（圖 11-3）

Continue to turn the body leftward, the center of gravity moves to the left,make a left bow step, at the same time, push the left hand to the front, wrist and shoulder at same level, the force reaches the root of the palm, keeps the right hook hand, look at the left hand. (Fig. 11-3)

12

第十二式 高探馬
High Pat on Horse

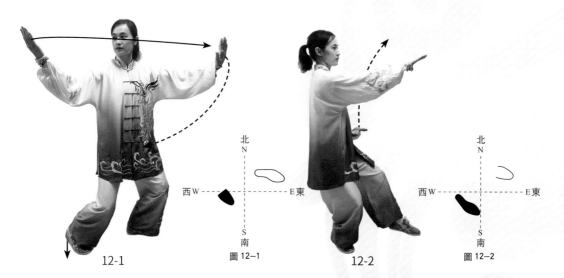

12-1 圖 12-1 12-2 圖 12-2

北 N / 西 W / E 東 / S 南

1、跟步變掌 Right foot half-step forward and palm outward

身體微右轉，右腳向左腳後側跟進半步，同時右勾手變掌再外旋翻掌，掌心向上，目視右手。（圖 12-1）

Turn the body slightly rightward, move the right foot half-step forward, with the toes on the ground, at the same time, release right hook hand to palm, palm facing upwards, look at the right hand. (Fig. 12-1)

2、虛步推掌 Empty step and push arm

身體左轉，右掌經右耳側向前推出，掌心向前，腕與肩平，左手外旋收至左腰側，掌心向上，同時重心移至右腳，左腳微提起再向前移，腳尖點地，成左虛步，目視右手。（圖 12-2）

Turns the body leftward, push the right palm forward, wrist and shoulder at same level,rotate the left hand externally to the left waist, palm facing upwards, at the same time, the center of gravity moves to the right foot,the left foot slightly lifts and then points forward, the toes on the ground to form the left empty stance, look at the right hand. (Fig. 12-2)

第十三式 右蹬腳
Kick with Right Heel

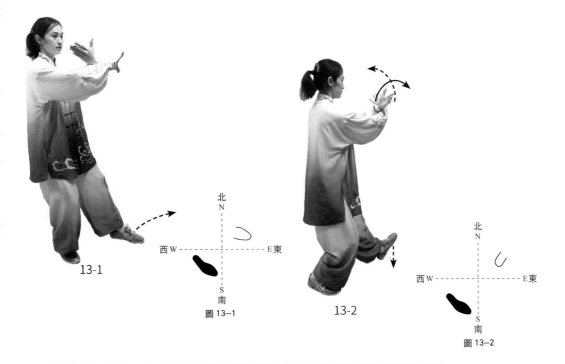

13-1

圖 13—1

13-2

圖 13-2

1、右轉穿掌 Turn the body right and cross palm

身體微右轉，左掌上穿至右手前臂內側，掌心向內，目視前方。（圖 13-1）

Turn the body slightly to the right, cross left palm on top of the right forearm, left palm facing inwards, look straight ahead. (Fig. 13-1)

2、左轉上步 Turn the body left and step forward

身體左轉，左腳向左前上步，目視兩掌。（圖 13-2）

Turn the body leftward, left foot steps forward to the left, look at both hands. (Fig. 13-2)

13 第十三式 右蹬腳
Kick out Right Heel

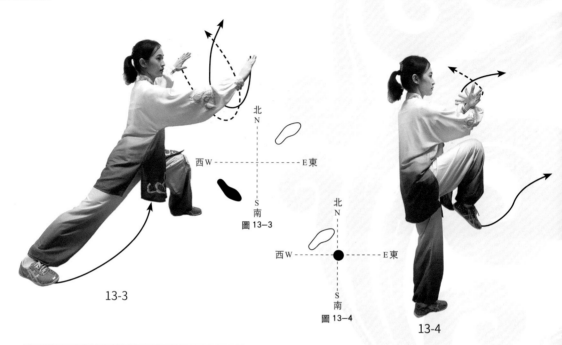

圖 13-3

13-3

圖 13-4

13-4

3、弓步分掌 Bow stance and open palms

身體左轉，左腳前弓，右腳後蹬，成左弓步，同時兩臂向兩側劃弧分開，掌心向外，目視右掌。（圖 13-3）

Turn the body leftward,the center of gravity moves to the left,make a left bow step, at the same time, both arms open in an arc, palms facing outward, look at right hand. (Fig. 13-3)

4、提膝合臂 Lift knee and close arms

身體微左轉，兩臂劃弧相合於胸前，掌心向內，同時提右膝，目視兩掌。（圖 13-4）

Turn the body slightly leftward,arms draw a downward arc and come together in front of the chest, palms facing inwards, at the same time, lift right knee, look at both hands. (Fig. 13-4)

第十三式 右蹬腳
Kick out Right Heel

5、蹬腳分掌 Kick heel and open arms

身體右轉，右腳以腳跟為力點向右前方蹬出，同時兩臂劃弧分開，右臂和右腿上下相對，目視右掌。（圖 13-5）

Turn the body rightward, kick out the right foot,the force will be on the right heel, at the same time, open arms in an arc movement, right arm above right leg, look at the right hand. (Fig. 13-5)

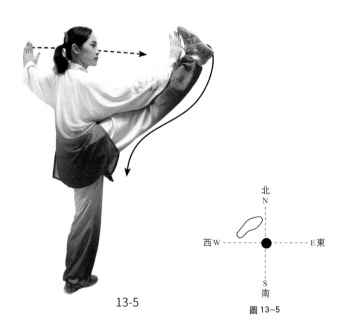

13-5

圖 13-5

14 第十四式 雙峰貫耳

Strike Opponent's Ears with Both Fists

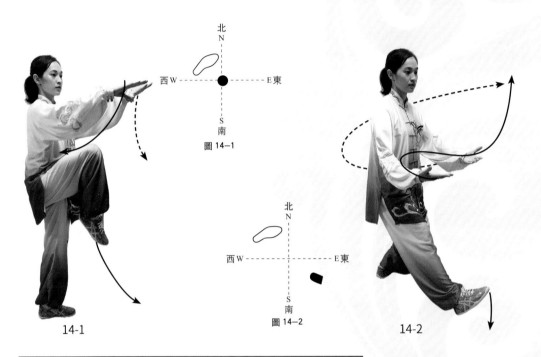

14-1

圖 14-1

圖 14-2

14-2

1、屈膝合掌 Bend knee and close palms

右小腿屈膝回收，腳尖下垂，同時左手向右與右手相合，掌心向下，目視兩掌。（圖 14-1）

Bend the right knee downwards, at the same time, move the left hand to the right in an arc movement, both palms facing downwards, look at both hands. (Fig. 14-1)

2、落腳翻掌 Drop foot and turn over palms

右腳向右前方下落，同時兩臂外翻，掌心斜向上，目視前方。（圖 14-2）

Right foot lands on the front right, at the same time, curl both arms with palms facing downwards to the waist, look straight ahead. (Fig. 14-2)

第十四式 雙峰貫耳

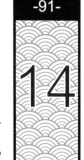

14

Strike Opponent's Ears with Both Fists

3、 弓步貫拳 Bow stance and strike with both fists

身體右轉，右腳前弓，左腳後蹬，成右弓步，同時兩掌變拳劃弧向前貫打，拳眼斜向下，目視兩拳。（圖 14-3）

Turn the body rightward, the center of gravity moves to the right,make a right bow step, at the same time,strike both fists to opponent's ears in an arc movement, and fist-eyes in an oblique downwards direction, look at both fists. (Fig. 14-3)

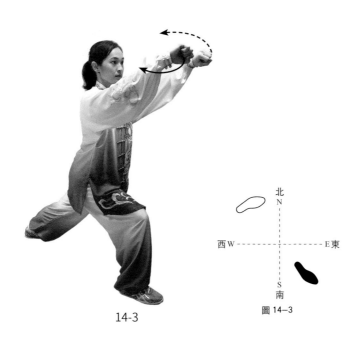

14-3

圖 14—3

第十五式 轉身左蹬腳
Turn Body and Kick out Left Heel

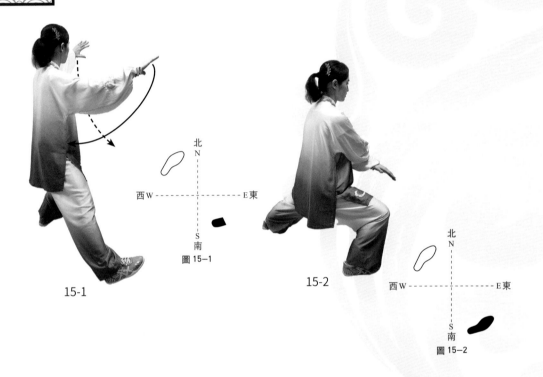

15-1

圖 15-1

15-2

圖 15-2

1、 後坐變掌 Sit back and fists become palms

身體左轉，重心左移，右腳尖上翹，同時兩拳變掌劃弧分開，目視左掌。（圖 15-1）

Turn the body leftward, shift the body weight to the left, right toes above the ground, at the same time,fists become palms and curl in an arc form, look at the left hand. (Fig. 15-1)

2、 右移合掌 Shift weight to right and cross palms

重心右移，兩掌下落至腹前，目視前方。（圖 15-2）

Shift the body weight to the right, crossing both palms downward to the abdomen, look straight ahead. (Fig. 15-2)

第十五式 轉身左蹬腳

Turn Body and Kick out Left Heel

3、提膝合臂 Lift knee and close arms

兩臂劃弧相合於胸前，左手在外，掌心向內，同時提左膝，目視兩掌。（圖 15-3）

Both arms move in an arc form,and cross them in front of the chest, left hand in front of right hand,palms facing inwards, at the same time, lift left knee, look at both hands. (Fig. 15-3)

4、蹬腳分掌 Kick out heel and open arms

身體右轉，左腳以腳跟為力點向左前方蹬出，同時兩臂劃弧分開，左臂和左腿上下相對，目視左掌。（圖 15-4）

Turn the body rightward, kick out the left foot,the force will be on the left heel, at the same time, open arms in an arc movement, left arm above left leg, look at the left hand. (Fig. 15-4)

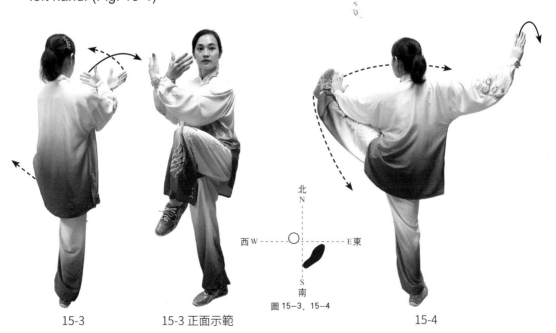

北
N

西 W ----- ○ ----- E 東

S
南

圖 15-3、15-4

15-3 15-3 正面示範 15-4

16

第十六式 左下勢獨立
Left Downward Posture With Left Single Leg Stance

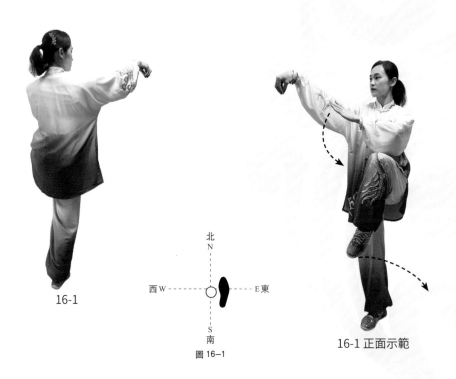

16-1

北
N

西 W ---------○--------- E 東

S
南

圖 16-1

16-1 正面示範

1、垂腿勾手 Curl left knee and right hook hand

身體右轉，左腳屈膝回收，腳尖下垂，同時右掌變勾手，左掌經面前劃弧至右肩前，目視右勾手。（圖 16-1）

Turn the body rightward, curl left knee, toes point downwards, at the same time, right palm forms hook hand, left palm moves towards to the face and right shoulder in an arc form, look at the right hook hand. (Fig. 16-1)

第十六式 左下勢獨立

Left Downward Posture With Left Single Leg Stance

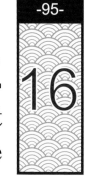

16

16-2

北
N

西W ——————E 東

S
南
圖 16—2

16-2 正面示範

2、屈膝撤步 Bend knee and step backward

右腿屈膝，左腳向左後方撤步，腳掌先著地，左掌下落至腰前，目視左腳。（圖16-2）

Bend right knee, step out the left foot toes slightly backwards to the left, left hand downward to the waist, look at the left foot. (Fig. 16-2)

16 第十六式 左下勢獨立
Left Downward Posture With Left Single Leg Stance

3、僕步穿掌 Drop stance and cross palms

身體左轉，右腿繼續下蹲成僕步，左掌經腹前沿左腿向左穿出，掌心向右，目視左手。
（圖 16-3）

Turn the body leftward, squarts down the right foot to form a drop stance, extend left palm along the inside edge of left leg, left palm facing rightward, look at the left hand. (Fig. 16-3)

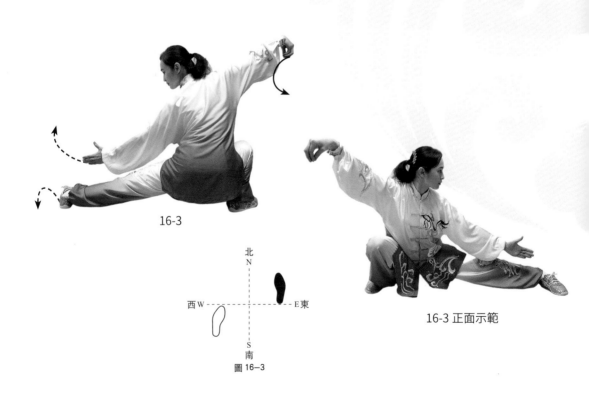

16-3

北
N

西W ———————— E東

S
南
圖 16-3

16-3 正面示範

第十六式 左下勢獨立

Left Downward Posture With Left Single Leg Stance

16

4、弓步穿掌 Bow stance and extend palm

身體繼續左轉，左腳前弓，右腳後蹬，成左弓步，同時左掌向左前穿，右勾手內旋，勾尖向上，目視左手。（圖 16-4）

Turn the body leftward, the center of gravity moves to the left,make a left bow step,at the same time, lift up the left palm to the front, right hook hand turns inwards, hook tip upward, look at the left hand. (Fig. 16-4)

5、提膝挑掌 Lift knee and palm

重心全部移至左腿，右腿屈膝上提，腳尖下垂，同時右勾手變掌上挑，掌心向左，左掌下按至左胯旁。（圖 16-5）

Move whole body weight to the left leg, lift up the right knee, toes downward, at the same time, right hook hand changes to palm and lift up the palm, right palm facing left, left palm pressing down to the left hip. (Fig. 16-5)

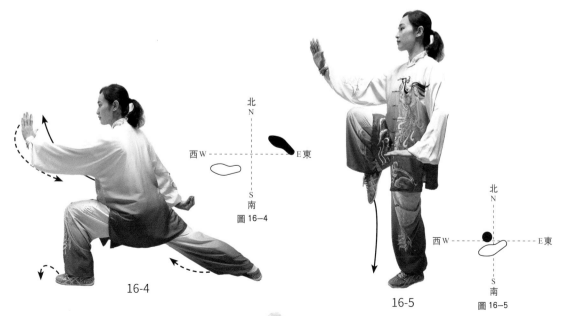

16-4

圖 16—4

16-5

圖 16-5

17 第十七式 右下勢獨立
Right Downward Posture With Right Single Leg Stance

1、落腳勾手 Drop foot and hook hand

右腳在左腳前下落，腳尖先著地，左腳以腳掌為軸碾轉，左掌變勾手上提，右掌經面前劃弧至左肩前，目視左手。（圖 17-1、17-2）

Drop the right toes forwards, raise the left heel and turn right, left palm changes to hook hand and lift up, right palm moves towards to the face and left shoulder in an arc form,look at the left hook hand. (Fig. 17-1、17-2)

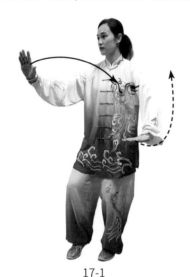

17-1

圖 17-1、17-2

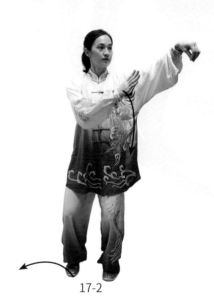

17-2

第十七式 右下勢獨立

Right Downward Posture With Right Single Leg Stance

2、屈膝撤步 Bend knee and step backward

左腿屈膝，右腳向右後方撤步，腳掌先著地，右掌下落至腰前，目視右腳。（圖 17-3）

Bend left knee, step out the right foot toes slightly backwards to the right, right hand downward to the waist, look at the right foot. (Fig. 17-3)

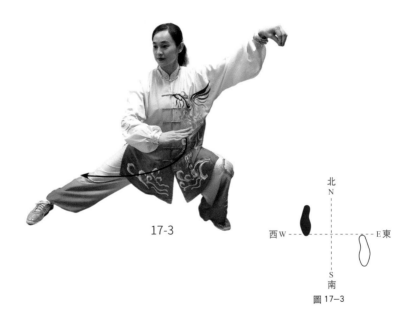

17-3

北
N

西W —————————————— E東

S
南

圖 17-3

17

第十七式 右下勢獨立
Right Downward Posture With Right Single Leg Stance

3、 僕步穿掌 Drop stance and cross palms

身體右轉，左腿繼續下蹲成僕步，右掌經腹前沿右腿向右穿出，掌心向左，目視右手。（圖 17-4）

Turn the body rightward, squarts down the left foot to form a drop stance, extend right palm along the inside edge of right leg, right palm facing leftward, look at the right hand. (Fig. 17-4)

4、 弓步穿掌 Bow stance and extend palm

身體繼續右轉，右腳前弓，左腳後蹬，成右弓步，同時右掌向右前穿，左勾手內旋，勾尖向上，目視右手。 （圖 17-5）

Turn the body rightward, the center of gravity moves to the right,make a right bow step,at the same time,lift up the right palm to the front, left hook hand turns inwards, hook tip upward, look at the right hand. (Fig. 17-5)

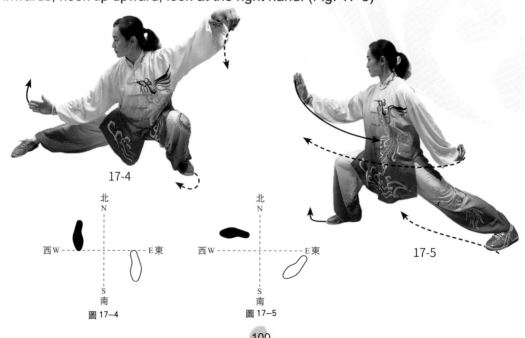

17-4

17-5

圖 17—4

圖 17—5

第十七式 右下勢獨立
Right Downward Posture With Right Single Leg Stance

5、提膝挑掌 Lift knee and palm

重心全部移至右腿，左腿屈膝上提，腳尖下垂，同時左勾手變掌上挑，掌心向右，右掌下按至右胯旁。（圖 17-6）

Move whole body weight to the right leg, lift up the left knee, toes downward, at the same time, left hook hand changes to palm and lift up the palm, left palm facing right, right palm pressing down to the right hip. (Fig. 17-6)

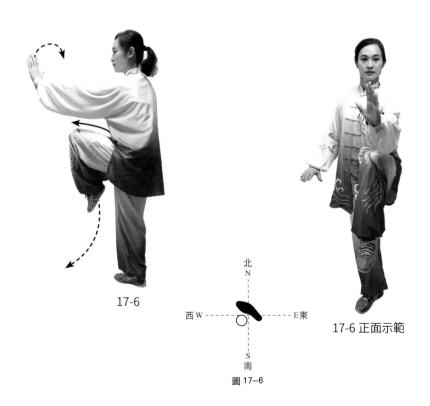

17-6

北
N
西 W ┈┈┈┈┈ E 東
S
南
圖 17-6

17-6 正面示範

18 第十八式 左右穿梭
Work at Shuttles on Both Sides

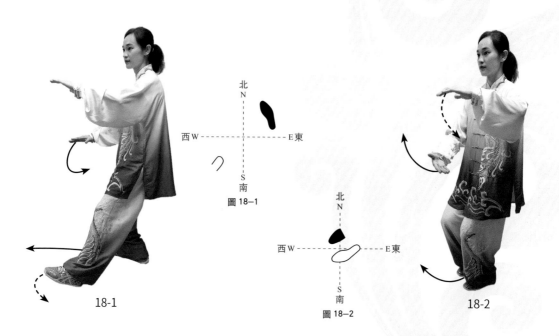

北
N

西W - - - - - - - - E東

S
南
圖 18−1

18-1

北
N

西W - - - - - - - - E東

S
南
圖 18−2

18-2

1、左轉上步 Turn left and step forward

身體左轉，右腿屈膝，左腳向左前方下落，腳跟先著地，目視左手。（圖 18-1）

Turn the body leftward, bend right knee, drop the left foot to the front left with heel on the ground, look at the left hand. (Fig. 18-1)

2、丁步抱球 Left T-step and hold ball

重心移至左腳，兩掌在左胸前合抱，左手屈臂收在胸前，掌心向下，右手劃弧收至左胯前，掌心向上，同時右腳收到左腳內側，腳尖點地，目視左手。（圖 18-2）

Move the center of gravity to the left foot, both palms facing each other in front of the left chest, bend the left arm in front of the chest, palm facing down, right hand to the left hip, palm up,keep the right foot in T-step inside of the left foot, look at the left hand. (Fig.18-2)

第十八式 左右穿梭

Work at Shuttles on Both Sides

3、上步滾掌 Step forward and roll palms

身體右轉，右腳向右前方上步，同時兩掌成滾球勢，目視右前方。（圖 18-3）

Turn the body rightward, step the right foot forward, at the same time, roll both palms as rolling a ball, look at front right. (Fig. 18-3)

4、弓步架推 Bow stance and cover push

身體繼續右轉，右腳前弓，左腳後蹬，成右弓步，同時右掌內旋上架至右額上方，左掌向右前方推出，目視左手。（圖 18-4）

Continue to turn the body rightward, the center of gravity moves to the right, make a right bow step, at the same time, rotates the right palm inwards and lift to the right forehead, push out the left palm, look at the left hand. (Fig. 18-4)

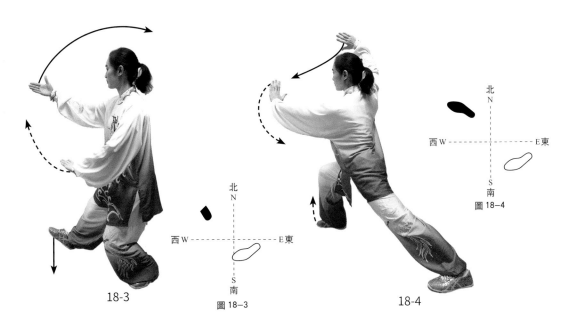

18-3

圖 18-3

18-4

圖 18-4

18 第十八式 左右穿梭
Work at Shuttles on Both Sides

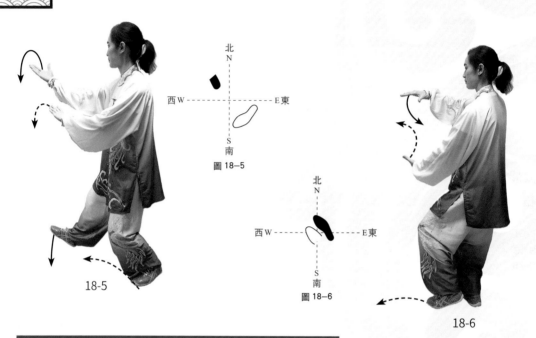

北
N

西 W ──────── E 東

S
南
圖 18-5

18-5

北
N

西 W ──────── E 東

S
南
圖 18-6

18-6

5、 左轉翻掌 Turn left turn over palm

身體左轉，重心左移，右腳尖上翹，右掌外旋下落，掌心向上，目視右手。（圖 18-5）

Turn the body left, the center of gravity moves to the left, right toes above the ground, right palm rotates externally and brings down, palm facing upward, look at the right hand. (Fig. 18-5)

6、 丁步抱球 Left T-step and hold ball

重心移至右腳，兩掌在右胸前合抱，右手屈臂收在胸前，掌心向下，左手劃弧收至右胯前，掌心向上，同時左腳收到右腳內側，腳尖點地，目視右手。（圖 18-6）

Move the center of gravity to the right foot, both palms facing each other in front of the right chest, bend the right arm in front of the chest, palm facing down, left hand to the right hip, palm up,keep the left foot in T-step inside of the right foot, look at the right hand. (Fig.18-6)

第十八式 左右穿梭 18
Work at Shuttles on Both Sides

7、上步滾掌 Step forward and roll palms

身體左轉，左腳向左前方上步，同時兩掌成滾球勢，目視左前方。（圖 18-7）

Turn the body leftward, step the left foot forward, at the same time, roll both palms as rolling a ball, look at front left. (Fig. 18-7)

8、弓步架推 Bow stance and cover push

身體繼續左轉，左腳前弓，右腳後蹬，成左弓步，同時左掌內旋上架至左額上方，右掌向左前方推出，目視右手。（圖 18-8）

Continue to turn the body leftward, the center of gravity moves to the left,make a left bow step, at the same time,rotates the left palm inwards and lift to the left forehead, push out the right palm, look at the right hand. (Fig. 18-8)

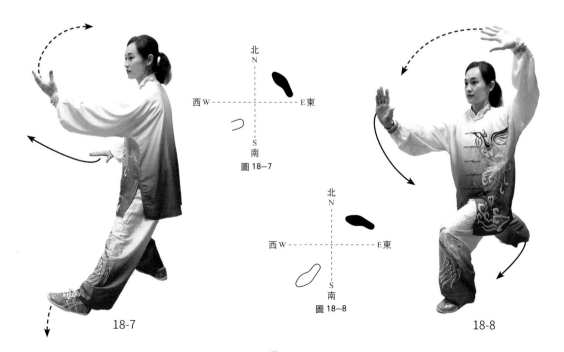

北
N

西W ---------- E東

S
南
圖 18—7

北
N

西W ---------- E東

S
南
圖 18—8

18-7

18-8

19 第十九式 海底針
Needle at Sea Bottom

1、跟步提按 Right foot half-step forward and lift press

右腳跟上半步，重心右移，左腳微提起，右掌劃弧上提，掌心向左，同時左掌劃弧向右按掌，掌心向下，目視前方。（圖 19-1、19-2）

Right foot half-step forward, the center of gravity moves to the right, lift left foot slightly upward, lift up the right palm in an arc form, palm facing leftward, at the same time, press the left palm to the right in an arc form, palm facing downward, look straight ahead. (Fig. 19-1、19-2)

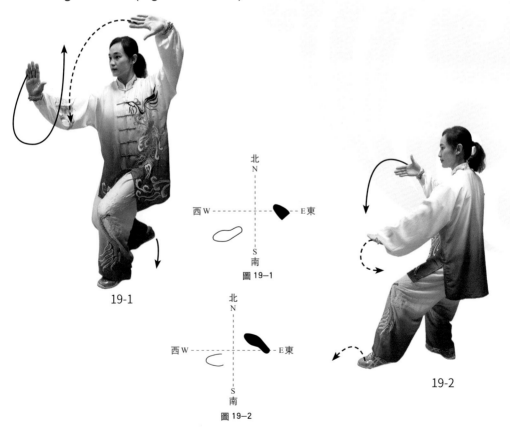

19-1

北 N
西 W — — — — — E 東
S 南
圖 19—1

北 N
西 W — — — — — E 東
S 南
圖 19—2

19-2

第十九式 海底針 19
Needle at Sea Bottom

2、虛步插掌 Left empty step and plunge down right palm

身體左轉，左腳腳尖點地，同時左手向左摟掌至左胯旁，右掌劃弧向前下方插掌，掌心向左，指尖斜向下，目視右手。（圖 19-3）

Turn the body leftward, with left toes on the ground, at the same time, move left hand to the left hip, plunge down the right palm, palm facing leftward, fingers pointing down, look at the right hand. (Fig. 19-3)

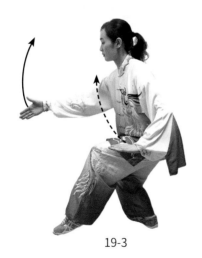

19-3

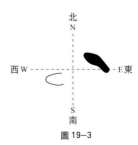

北
N

西 W ----- ┼ ----- E 東

S
南

圖 19-3

第二十式 閃通背
Flash arms Through Back

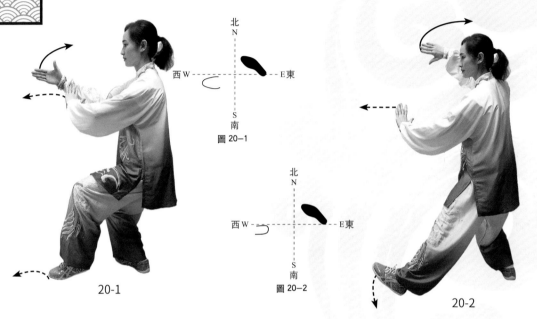

20-1

圖 20-1

圖 20-2

20-2

1、提腳合臂 Lift foot and close arm

身體右轉，左腳微提起，右掌回抽，左掌上穿與右臂相合，掌心向右，目視前方。（圖 20-1）

Turn the body rightward, lift left foot slightly up, draw the right palm backward, at the same time, lift the left palm upwards together with the right arm, right palm facing rightward, look straight ahead. (Fig. 20-1)

2、上步架掌 Step forward and block palm

身體左轉，左腳向前上步，腳跟著地，同時右臂內旋上架，目視前方。（圖 20-2）

Turn the body leftward, step the left foot forward, with heel on the ground, at the same time, rotate the right arm internally upward, look straight ahead. (Fig. 20-2)

第二十式 閃通背
Flash arms Through Back

20

3、弓步架推 Bow step and block push

身體繼續左轉，左腳前弓，右腳後蹬，成左弓步，同時左手向前推出，腕與肩平，力達掌根，右臂至右額旁，拇指向下，掌心向外，目視左手。（圖 20-3）

Continue to turn the body leftward, the center of gravity moves to the left, make a left bow step, at the same time, push the left hand forward, wrist and shoulder at same level, the point of force at base of the left palms, right arm lies beside the forehead, thumb downward, right palm facing outwards, look at the left hand. (Fig. 20-3)

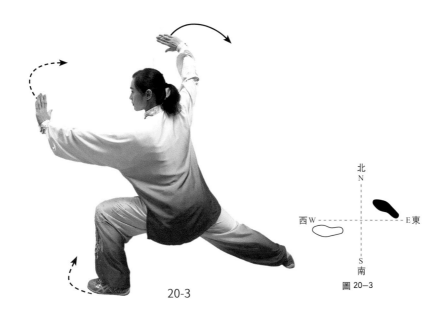

20-3

北
N

西 W ———————— E 東

S
南

圖 20-3

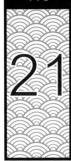

21

第二十一式 轉身搬攔捶

Turn Body Rightward, Deflect Downward, Parry and Punch

1、後坐扣腳 Sit back and foot internal buckle

身體右轉，重心右移，左腳尖內扣，右掌變拳劃弧下落右胯前，目前前方。（圖 21-1、21-2）

Turn the body rightward, the center of gravity moves to the right, turn the right toes inward, change the right palm to fist,and press down to the right hip in an arc form, look straight ahead. (Fig. 21-1、21-2)

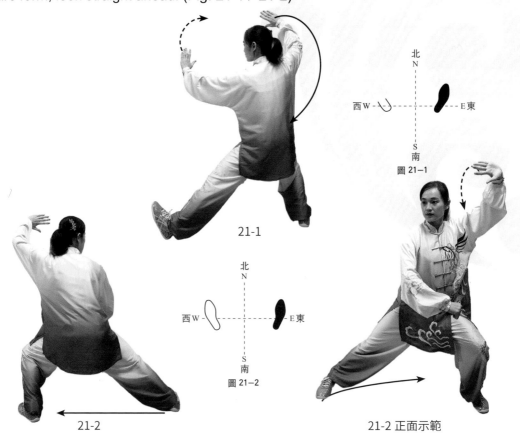

21-1

圖 21—1

21-2

圖 21—2

21-2 正面示範

第二十一式 轉身搬攔捶

Turn Body Rightward, Deflect Downward, Parry and Punch

21

2、 收腳按掌 Right T-step and press left palm

身體繼續右轉，重心左移，右腳收至左腳內側，同時右拳收至左肘內下側，拳眼向內，目視右前方。 （圖 21-3）

Continue to turn the body rightward, the center of gravity moves to the left, keep the right toes in T-step inside of the left foot, at the same time, rest the right fist and to the inside of left elbow, with fist-eye inwards, look at the front right. (Fig. 21-3)

21-3

北
N
西W ———— E 東
S
南

圖 21—3

21-3 正面示範

第二十一式 轉身搬攔捶

Turn Body Rightward, Deflect Downward, Parry and Punch

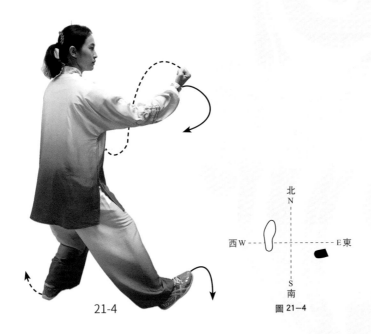

21-4

圖 21-4

北
N

西 W ———— E 東

S
南

3、上步搬拳 Step forward and deflect downward

身體右轉，右腳向前上步，同時右拳經胸前向前搬拳，左掌下落至左胯旁，目視右拳。（圖 21-4）

Turn the body rightward, step forward the right foot , at the same time, deflecting the right fist downward from the chest, rest the left palm to the left hip, look at the right fist. (Fig. 21-4)

第二十一式 轉身搬攔捶
Turn Body Rightward，Deflect Downward，Parry and Punch

4、撇腳攔掌 Twist the right toes outwards and parry palm

身體繼續右轉，撇右腳尖，同時右臂螺旋向右至右後方，左臂向右攔掌，掌心向上，目視左手。（圖 21-5）

Continue to turn right, Twist the right toes outwards,at the same time,rotate the right arm from front to back, parry the left arm to the right, look at the left hand. (Fig. 21-5)

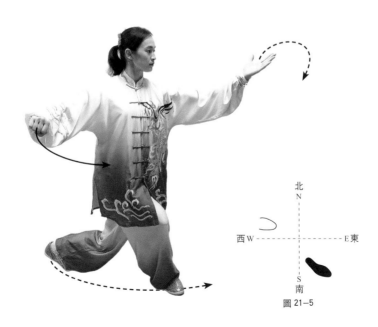

圖 21-5

21

第二十一式 轉身搬攔捶

Turn Body Rightward, Deflect Downward, Parry and Punch

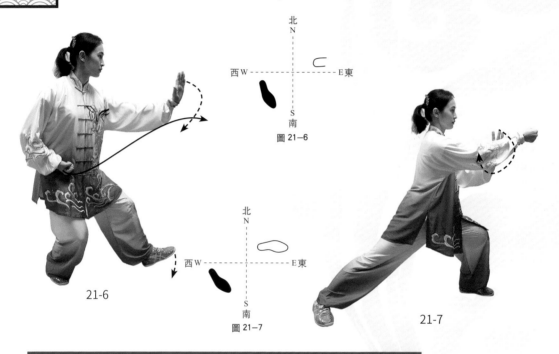

21-6

圖 21-6

圖 21-7

21-7

5、 上步收拳 Step forward and withdraw fist

左腳向前上步，左手內旋，右拳劃弧收至右腰間，目視左掌。 （圖 21-6）

Step forward left foot, rotate the left palm inwards, move back the right fist to the right waist, look at the left palm. (Fig. 21-6)

6、 弓步打拳 Bow step and punch

身體左轉，左腳前弓，右腳後蹬，成左弓步，同時右拳向前螺旋打出，拳眼向上，左掌附於右臂內側，目視右拳。 （圖 21-7）

Turn the body leftward, the center of gravity moves to the left,make a left bow step, at the same time, punch forward the right fist, with fist-eye upwards, left palm beside the inside of right forearm, look at the right fist. (Fig. 21-7)

第二十二式 如封似閉

Apparent Close Up

1、穿手變掌 Cross hand and change fist to palm

左掌經右臂下側向前穿出，同時右拳變掌，兩掌分開，掌心向上，目視前方。（圖 22-1、22-2）

Lower the left palm below the right arm and slide forward, at the same time,change the right fist to palm, part out both palms,and facing them upward, look straight ahead. (Fig. 22-1、22-2)

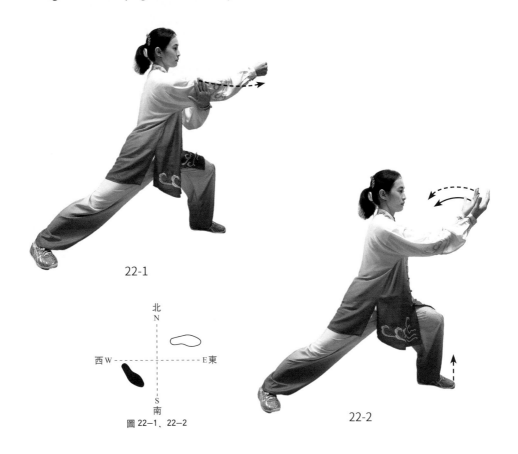

22-1

北
N

西 W ———— E 東

S
南

圖 22-1、22-2

22-2

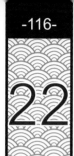

22

第二十二式 如封似閉
Apparent Close Up

2、後坐收掌 Sit back and move palms backward

重心右移，左腳尖上翹，同時兩臂向後屈臂回收，掌心向內，目視兩掌。（圖 22-3）

The center of gravity moves to the right, left toes above the ground, at the same time, bend elbows and move both arms backwards, palms facing inwards, look at both palms. (Fig. 22-3)

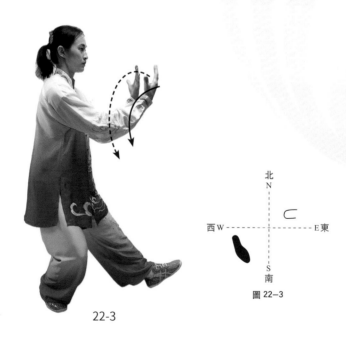

22-3

圖 22-3

第二十二式 如封似閉

Apparent Close Up

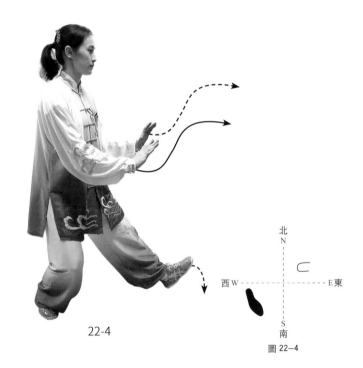

22-4

圖 22-4

3、翻掌下按 Turn palms and press down

兩臂內旋，兩掌翻轉向下按掌，目視前方。（圖 22-4）

Rotate both arms internally,press both palms downward, look straight ahead. (Fig. 22-4)

22

第二十二式 如封似閉
Apparent Close Up

4、弓步前按 Bow step and press forward

身體左轉，左腳前弓，右腳後蹬，成左弓步，同時兩掌自下向上、向前推掌，腕於肩平，力達掌根，目視前方。（圖 22-5）

Turn the body leftward, the center of gravity moves to the left,make a left bow step, at the same time, press both palms downwards,and push them upward and forward, with wrist and shoulder at same level, with force pointing at the root of the palm, look straight ahead. (Fig. 22-5)

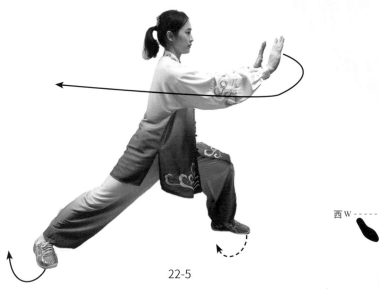

22-5

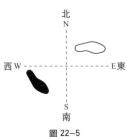

北
N

西W ---------- E東

S
南

圖 22-5

第二十三式 十字手
Cross Hands
23

1、右轉分掌 Turn right and open palms

身體右轉，重心右移，左腳尖內扣，右腳尖外擺，同時兩手劃弧分開，腕與肩平，目視右手。（圖 23-1）

Turn the body rightward, the center of gravity moves to the right, turn the left toes to the right, turn the right toes outwards, at the same time, draw both arms are apart in an arc form, with wrist and shoulder at same level, look at he right hand. (Fig. 23-1)

2、扣腳合臂 The foot internal buckle and cross arms

身體左轉，重心左移，右腳尖內扣，同時兩臂向下交叉合臂，左臂在外，兩掌掌心均向內，目視前方。（圖 23-2）

Turn the body leftward, the center of gravity moves to the left, turn the right toes to the left, at the same time, move both arms downward and cross them, the left hand is on top of the right hand, both palms face downwards, look straight ahead. (Fig. 23-2)

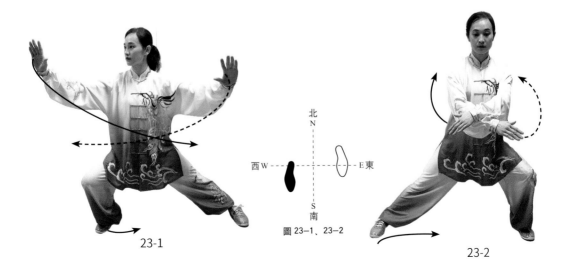

圖 23-1、23-2

23-1

23-2

23

第二十三式 十字手
Cross Hands

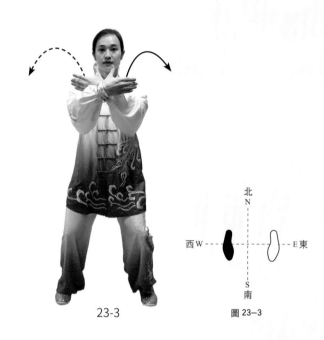

23-3

圖 23-3

3、收腳合臂 Withdraw foot and cross arms

身體微右轉，右腳收回至左腳內側，成開立步，與肩同寬，同時兩臂外旋上舉，成十字手，右手在外，腕與肩平，兩掌掌心均向內，目視前方。（圖 23-3）

Turn the body slightly to the right, move the right foot to the left foot, and form an upright stance, with feet at shoulder-width, at the same time, rotate both arms externally and cross both hands upward, the right hand is outside, with wrist and shoulder at same level, both palms facing inwards, look straight ahead. (Fig. 23-3)

【太極扇】

武術/廣場舞/表演扇
可訂制LOGO

紅色牡丹　　　　粉色牡丹　　　　黃色牡丹　　　　紫色牡丹

黑色牡丹　　　　藍色牡丹　　　　綠色牡丹　　　　黑色龍鳳

紅色武字　　　　黑色武字　　　　紅色龍鳳　　　　金色龍鳳

純紅色　　　　　紅色冷字　　　　紅色功夫扇　　　紅色太極

打開淘寶天貓APP
掃碼進店

微信掃一掃
進入小程序購買

【專業太極刀劍】

晨練/武術/表演/太極劍

打開淘寶天貓
掃碼進店

手工純銅太極劍

神武合金太極劍

桃木太極劍

平板護手太極劍

手工銅錢太極劍

鏤空太極劍

手工純銅太極劍

神武合金太極劍

劍袋·多種顏色、尺寸選擇

銀色八卦圖伸縮劍

銀色花環圖伸縮劍

龍泉寶刀

棕色八卦圖伸縮劍

紅棕色八卦圖伸縮劍

微信掃一掃
進入小程序購買

123

【學校學生鞋】

多種款式選擇・男女同款

可定制logo

檢測報告

商品注册證

打開淘寶天貓APP

掃碼進店

微信掃一掃

進入小程序購買

【武術/表演/比賽/專業太極鞋】

打開淘寶天貓
掃碼進店

微信掃一掃
進入小程序購買

正紅色【升級款】
XF001 正紅

藍色【經典款】
XF8008-2 藍

黃色【經典款】
XF8008-2 黃色

紫色【經典款】
XF8008-2 紫色

正紅色【經典款】
XF8008-2 正紅

黑色【經典款】
XF8008-2 黑

綠色【經典款】
XF8008-2 綠

桔紅色【經典款】
XF8008-2 桔紅

粉色【經典款】
XF8008-2 粉

XF2008B（太極圖）白

XF2008B（太極圖）黑

XF2008-2 白

XF2008-3 黑

5634 白

XF2008-2 黑

【太極羊 · 專業武術鞋】

兒童款 · 超纖皮

XF808-1 銀

XF808-1 白

XF808-1 紅

XF808-1 金

XF808-1 藍

XF808-1 黑

XF808-1 粉

微信掃一掃

進入小程序購買

短袖款

长袖款

【專業太極服】

多種款式選擇・男女同款

微信掃一掃

進入小程序購買

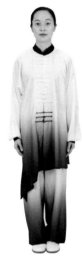

黑白漸變仿綢

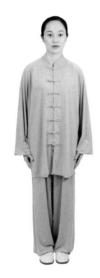

淺棕色牛奶絲

白色星光麻

亞麻淺粉中袖

白色星光麻

真絲綢藍白漸變

 香港國際武術總會

中華武術

火熱招生中......

地址：香港九龍尖沙咀梳士巴利道3號星光行六樓612-615室

電話：(852) 97984638 /23081086

香港國際武術總會裁判員、教練員培訓班
常年舉辦培訓

　　香港國際武術總會培訓中心是經過香港政府注冊、香港國際武術總會認證的培訓部門。爲傳承中華傳統文化、促進武術運動的開展，加強裁判員、教練員隊伍建設，提高武術裁判員、教練員綜合水平，以進一步規範科學訓練爲目的，選拔、培養更多的作風硬、業務精、技術好的裁判員、教練員團隊。特開展常年培訓，報名人數每達到一定數量，即舉辦培訓班。

報名條件：熱愛武術運動，思想作風正派，敬業精神强，有較高的職業道德，男女不限。

培訓内容：1.規則培訓；2.裁判法；3.技術培訓。考核内容：1.理論、規則考試；2.技術考核；3.實際操作和實踐(安排實際比賽實習)。經考核合格者頒發結業證書。培訓考核優秀者，將會録入香港國際武術總會人才庫，有機會代表參加重大武術比賽，并提供宣傳、推廣平臺。

聯系方式

深圳：13143449091(微信同號)

　　　13352912626(微信同號)

香港：0085298500233(微信同號)

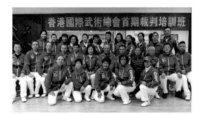

國際武術教練證　　國際武術裁判證

微信掃一掃

進入小程序

香港國際武術總會第三期裁判、教練培訓班

打開淘寶APP

掃碼進店

【出版各種書籍】

中英文版
English
★★★★

申請書號>設計排版>印刷出品
>市場推廣
港澳台各大書店銷售

冷先鋒

楊式簡化太極拳

Yang Style Simplified Tai Chi Chuan

高樹興 鄧敏佳 編著

書　　號: ISBN 978-988-75382-8-8
出　　版: 香港國際武術出版社
發　　行: 香港聯合書刊物流有限公司
代理商: 台灣白象文化事業有限公司
審　　定: 香港國際武術總會

香港地址: 香港九龍彌敦道 525-543 號寶寧大廈 C 座 412 室
電　　話: 00852-98500233 \91267932
深圳地址: 深圳市羅湖區紅嶺中路 2118 號建設集團大廈 B 座 20A 室
電　　話: 0755-25950376\13352912626
台灣地址: 401 台中市東區和平街 228 巷 44 號
電　　話: 04-22208589

印　　次: 2021 年 10 月第一次印刷
印　　數: 5000 冊
總 編 輯: 冷先鋒
裝幀設計: 明栩成
設計策劃: 香港國際武術總會工作室
網　　站: www.hkiwa.com　　Email: hkiwa2021@gmail.com

本書如有缺頁、倒頁等品質問題，請到所購圖書銷售部門聯繫調換。